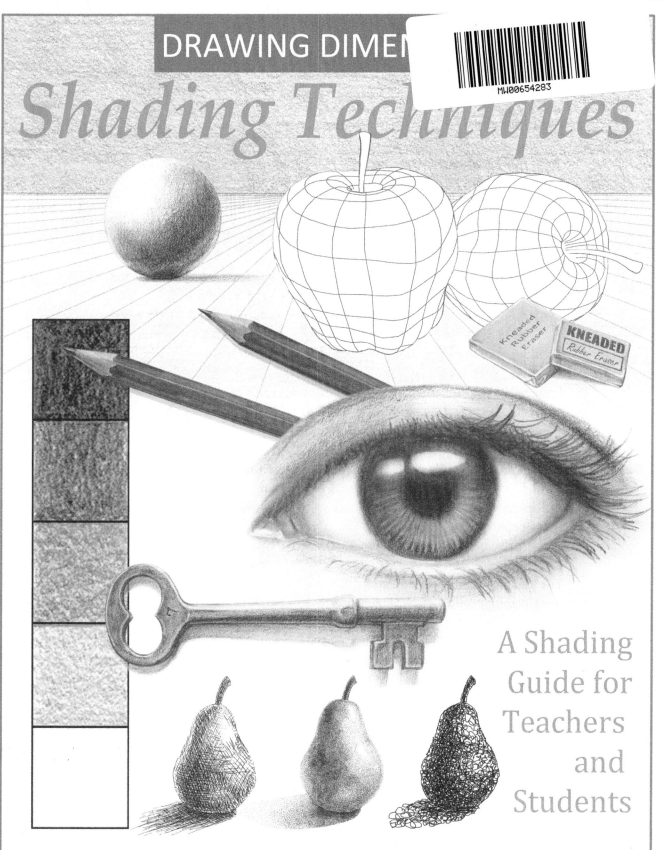

DRAWING DIMEN...

Shading Techniques

A Shading
Guide for
Teachers
and
Students

Catherine V. Holmes

Published by:
Library Tales Publishing
www.LibraryTalesPublishing.com
www.Facebook.com/LibraryTalesPublishing

Copyright © 2017 by Catherine V. Holmes
Published by Library Tales Publishing, Inc., New York, New York

For general information on our other products and services, please contact our Customer Care Department at 1-800-754-5016, or fax 917-463-0892. For technical support, please visit www.LibraryTalesPublishing.com

Library Tales Publishing also publishes its books in a variety of electronic formats. Every content that appears in print is available in electronic books.

** PRINTED IN THE UNITED STATES OF AMERICA **

ISBN-13:978-0692919842
ISBN-10: 0692919848
Library of Congress Control Number: 2017948516

SHADING TECHNIQUES
A Shading Guide for Teachers and Students

About the Author

Catherine V. Holmes is a mother, teacher, artist, youth advocate and author/illustrator of the "How To Draw Cool Stuff" series.

Holmes was formally trained at Boston University School for the Arts and is currently independently learning and exploring different techniques used for creating. She is not very particular about what she makes, as long as she is making something. Recently, Holmes has turned her attention to creating detailed dramatic play stations and sensory bins for her toddler twins.

Holmes believes that everyone deserves art. Although everyone has the desire to make, invent and do, art does not have to be created to be appreciated. Art is all around us and can be enjoyed whether we draw it, sing it, write it, read about it or simply view it. Art as it is the one element that makes us most human.

ACKNOWLEDGEMENTS

*Dedicated to Charlotte and Taya, the sources
that inspire me to be creative everyday.*

Thank you to Virginia Holmes Thayer, David Thayer, Kenneth Holmes, Kathleen Holmes, Jeff Costello, Marcia Pennington and Jay Costello for your continued love and support. Thank you to Craftsy for giving me the opportunity to teach through a new platform, Usher Morgan and Library Tales, Carrie King, Leonardo's Library, Annie, Kat, Dan and the crew from the Holbrook Public Library, the folks at Dennett Elementary, my fellow CES teachers, Norman Small, Carol Johnson, and my students for inspiring me.

VI

Other Titles in the How to Draw Cool Stuff Series

How to Draw Cool Stuff:
A Drawing Guide for Teachers and Students
This book shows simple step-by-step illustrations that make it easy for anyone to draw cool stuff with precision and confidence. These lessons will help you see line, shape, space and other elements in everyday objects and turn them into detailed works of art in just a few simple steps. The exercises in this book will help train your brain so you can visualize ordinary objects in a different manner, allowing you to see through the eyes of an artist. From photorealistic faces to holiday themes and tattoo drawings, How to Draw Cool Stuff makes drawing easier than you would think and more fun than you ever imagined!

How to Draw Cool Stuff: Basics, Shading, Texture, Pattern and Optical Illusions is the second book in the *How to Draw Cool Stuff* series. Inside you will find simple illustrations that cover the necessities of drawing cool stuff. Specific exercises are provided that offer step-by-step guidelines for drawing a variety of subjects. Each lesson starts with an easy-to-draw shape that will become the basic structure of the drawing. From there, each step adds elements to that structure, allowing the artist to build on their creation and make a more detailed image. Starting with the basic forms, the artist is provided a guide to help see objects in terms of simplified shapes. Instructions for shading to add depth, contrast, character and movement to a drawing are then covered.

How to Draw Cool Stuff: Holidays, Seasons and Events is a step-by-step drawing guide that illustrates popular celebrations, holidays and events for your drawing pleasure. From the Chinese New Year to April Fools' Day, Father's Day to Halloween, Christmas and New Year s Eve - this book covers over 100 fun days, holidays, seasons and events, and offers simple lessons that will teach you how to draw like a pro and get you in the spirit of whichever season it may be! The third book in the How To Draw Cool Stuff series, this exciting new title will teach you how to create simple illustrations using basic shapes and a drawing technique that simplifies the process of drawing, all while helping you construct height, width and depth in your work.

TABLE OF CONTENTS

INTRODUCTION

Welcome to *Drawing Dimension: Shading Techniques*. Shading is one of the easiest ways to add depth, contrast, character, and movement to your drawings. By shading and adding tone properly, an artist can greatly improve the quality of his or her drawings. This is a skill that can be learned and it is not a difficult skill to grasp, but it does take some practice. By controlling pencil pressure and stroke, understanding light, and having knowledge of blending techniques, an artist can enhance their work and offer the "wow" factor needed in order to make an artwork convincingly realistic.

Shading captures the variation in value within an image and describes the form of an object. The inclusion of highlights and shadows in an artwork takes a two-dimensional image that has width and height and adds depth, giving an artwork the appearance of having three-dimensional qualities. This revolves mainly around identifying light sources and replicating them to create shape and volume using contrast as opposed to just lines.

This book, based on my online Craftsy drawing class, *Drawing Dimension: Shading Techniques*, offers a series of shading tutorials that are easy to understand and apply, exploring ideas beyond simple step-by-step instruction. The reader is offered direction as well as a deeper look in to the learning process by nurturing technique and understanding. Along with instruction, there are three principles to each lesson: "Know," "Understand" and "Do." To truly grasp a concept in art, an artist needs to know about the techniques they are using, as well as understand how they're used and what they communicate in

order to be able to use them effectively. Knowing is to simply recognize the facts and basic vocabulary of an idea. To understand is to comprehend the core meaning and principles of that idea, enabling the artist to make important generalizations and use insight when creating or discussing a work. Understanding requires higher-order thinking and does not have just one answer. Doing is to create and demonstrate the skills learned. This can be a final product (artwork) but can also include analyzing, compare/contrast, creative problem solving, and speculating. Understanding and doing promotes thinking and independent learning. To just "know" an idea is often simply the recall of information or facts. There is often one right answer. It is through the understanding component where an artist truly grasps the relevance of a lesson or experience. Understanding can be transferred from one situation to another, applied to new situations and other projects, not just one lesson being taught. Understanding is not something that can be memorized. This book aims to help an artist understand.

We all have the desire to be creative. Since art is a skill that can be learned, not a talent that one is born with, we all have the ability to learn to draw and shade well. As a teacher, I understand that we process information in a variety of ways and show our creativity in different forms, which is why it is important for students to have a multitude of learning strategies to choose from when learning a new skill. I have included text, visuals, hands-on opportunities, and hopefully inspiration for you to explore and learn about shading techniques.

Since this book concentrates more on shading rather than drawing, some tracing and transfer procedures will be demonstrated so you can jump right into the shading process and don't have to be concerned about making a technically "correct" drawing. Use tracings or pre-drawn images to your advantage so you can focus on learning shading techniques without worrying about what you should draw. It is not uncommon for artists to look to existing works to inspire their creative process, as it can be comforting to use existing characters or scenes as a basis for work. This can be extremely helpful when first learning how to draw and shade. I would like to encourage you to be inspired by the examples in this book and build from them. As you progress through the lessons and begin to find an understanding of the concepts being taught, push yourself to apply the skills and knowledge toward your own ideas and subject matter, rather than to merely copy them.

First, we will discuss the basic principles of value as we create a drawing using only five tones based on a value scale. Second, we'll analyze objects to see how the shape and contour affects the way we shade. Third, you'll see why understanding your light source can be the most important part of shading as we create highlights and blend tones in an artwork based on real-life objects. Other types of shading—including hatching, crosshatching, and stippling techniques with pen—will be explored. Fourth, we'll discuss the importance of contrast to set a mood and create a focal point, and finally we'll put all of these skills together to create a drawing using a combination of techniques that is sure to impress. You'll find lots of resources to help you along the way through examples, tips on what you should aim for, and pitfalls to avoid. Each lesson is tailored to help you refine your shading techniques so you can add more depth and realism to your work.

Let's get started!

CHAPTER ONE
INTRODUCTION TO TOOLS

Know:
• There are a variety of tools an artist may choose to create art with.

Understand:
• Graphite pencils are available in many different grades ranging from soft to hard.
• Marks made by a common pencil are not as dynamic as those made by a range of artist pencils.
• When choosing a drawing paper, there are four things to consider: the surface quality of the paper, the weight of the paper, the finish and its content.
• Blending utensils can be helpful when combining tones to create realistic shade and shadow.
• The variety of erasers available can help to make an artwork appear more realistic.

Do:
Learn about and explore the variety of pencils, papers, blending, and eraser products available. Examine and practice the techniques each tool offers in order to experience them firsthand and discover which is best for your needs.

People have been drawing since the beginning of time as a form of beau-tification, symbolic expression, and communication. Early artists had to be creative and made their own tools from available resources to draw with, including burned wood for charcoal, sharp sticks to make carvings, and earth pigments mashed into paint. Luckily, we do not have to scavenge for mark-making tools like our clever ancestors and can choose from a wide array of materials. There are so many to choose from; in fact, it can be quite confusing. Finding high quality drawing materials that are right for you can be overwhelming with all of the choices available today. Just look down the art supply aisle of the nearest craft superstore and you will find hundreds of options for pencils alone. Any pencil can make a mark; however, artists need to decide which pencil best fits their needs. In order to make an artwork look more polished and dynamic, the proper type of pencil, eraser, paper, etc. should be considered.

Fortunately, finding the drawing materials needed to create a charismatic, realistically shaded artwork can be surprisingly simple amidst the sea of pen-cil sets and drawing accessories. With a few simple tools, an artist can begin shading right away without investing a considerable amount of money.

When shading a drawing, there are a few tools that an artist relies on to help create shadows and highlights within an artwork so that it appears more realistic and interesting.

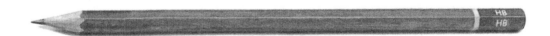

Pencils
The most obvious essential to an artist's toolkit are quality drawing pencils. Pencils are common writing utensils made of slender tubes of wood, metal, or plastic that contain a core of pigment. The pigment can be graphite, color, charcoal, or pastel (not lead as commonly believed). The lessons in this book will utilize pencils of the graphite variety. Graphite pencils are available in many different grades ranging from soft to hard. These grades are indicated on the end of a pencil in two ways: a numeric scale and an HB scale.
The HB scale uses letters to indicate how hard or soft a pencils mark will be while the numeric scale indicates the degree of hardness or softness.

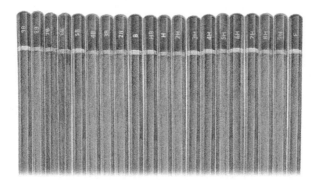

Artist pencils will usually have a number and a letter embossed or painted on the end of it. This combination of letters and numbers indicates the grade of the pencil and the hardness or lightness of the mark it makes. This grading system indicates the hardness of the core graphite (H, B, etc.) and the degree of hardness (2, 3, 4, 5, etc.).

If a pencil has an "H" on it, that letter indicates that it is a hard pencil. H pencils make light, sketchy lines, which are useful for drawing and sketching. The number in front of the H, ranging between 2 and 9, indicates how light the mark will be. The higher the number, the harder the writing core and the lighter the mark left on the paper. Therefore, a 9H pencil will leave a mark that is much lighter than a 2H. A 9H pencil will leave a hard, light line, great for mechanical drawings. Some scales will show an "F" grade between the "H" and the "HB." "F" often indicates "fine," "fine point," or "firm."

If a pencil has a "B" on it, that letter indicates that it is a soft pencil. B pencils make dark and smudgy marks, which are excellent for shading with. The higher the number, the softer the writing core and the darker the mark on the paper. Therefore, a 9B leaves a very soft, very dark, very intense mark, one that is much more intense than a 2B. Note that softer pencils (B) will dull faster than harder pencils and usually require more frequent sharpening.

ARTIST PENCIL GRADES

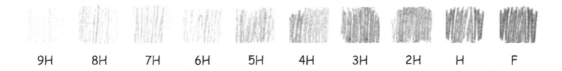

9H 8H 7H 6H 5H 4H 3H 2H H F

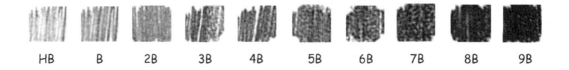

HB B 2B 3B 4B 5B 6B 7B 8B 9B

As you see in the pencil grades, the scale goes up to 9 at each end, 9H being the hardest and lightest mark maker to 9B being the softest and darkest mark maker. Both of these extreme ends of the scale are often too light or too dark for regular use.

Over time, an artist may tend to favor certain grades of pencils depending on their style and desired outcome of an artwork. As you learn how to shade and become more comfortable with the shading process, you will probably have a personal preference too. After years of drawing and shading, I prefer the results and ease of use offered in the middle B range. The 4B offers a soft, easy-to blend tone while still enabling the artist to render with some fine detail. The 6B is my ultimate favorite, which offers a dark mark that is very easy to blend. For very dark areas, the 8B is also useful.

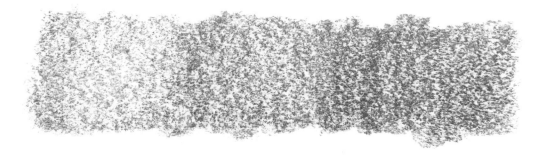

Here is a sample of the marks made by 4B, 6B, and 8B pencils laid down side by side. The difference between each mark is slight, so when they are placed down next to each other in a drawing, the three tones become a gradual, subtle blend.

Many artists will find that they do not use all of the pencils offered in pre-packaged drawing pencil sets. Pencil sets frequently come in portable cases or tins and usually include the full spectrum of graphite grades, but pencils can also be sold individually. It may be more logical to purchase a smaller range of pencils independently as opposed to a whole set. When shading, I utilize the 2B, 4B, and 6B pencils, so I often solely purchase the specific pencils I need. When it comes to drawing pencils, artists need to experiment with different brands and grades in order to decide what works best for them.

Many marks that can be made using art pencils can also be achieved with a common household pencil. Pencils marked with "HB," "2HB," or "2" are considered to be all-purpose, regular pencils, ones that you are most likely to use in school or at work. A regular pencil can be a passable tool to use in a pinch when sketching, but I would not recommend them if you are attempting to create a shaded masterpiece. Marks made by a common pencil are not as dynamic as those made by a range of artist pencils. Also, more work is involved when using a single pencil of any grade, as the pressure needs to be varied greatly. Save the common pencil for writing and purchase a few midrange B pencils if you don't want to commit to purchasing a whole set of artist pencils.

PAPER

Paper is a readily available source to write on and an important tool used when drawing that an artist needs to consider. Paper is the surface an artist draws on and is the literal foundation of their work. All papers are not created equally. When choosing a drawing paper, there are four things to consider: the quality of the paper, the weight of the paper, what it's made of (content), and the finish. There are different types of paper made to be used with different mediums. It may be tempting to grab a nearby piece of cheap printer paper or other non-drawing paper to create a masterpiece on, but that would be a mistake. The wrong type of paper can make your artwork appear flat and uninteresting, especially when shading in large areas of the same tone. Cheaper paper also makes it difficult for an artist to blend shades into one another with ease. Actual drawing papers can make shading look more realistic and can be easier for the artist to get results faster. Papers made especially for drawing will help the artist to achieve a tight consistency between tones. Also, higher quality drawing papers are made from cotton or linen fibers, which makes them more resistant to chemical breakdown and degrading over time. Archival papers are of the highest quality, acid-free papers are of medium quality, and other papers are best used for sketching.

Things to consider when deciding on what paper is best for you:

SURFACE

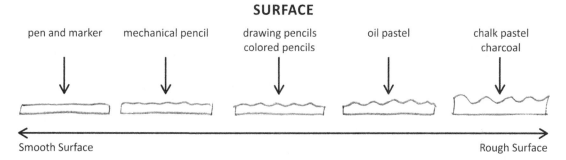

pen and marker | mechanical pencil | drawing pencils colored pencils | oil pastel | chalk pastel charcoal

Smooth Surface ←——————————————————→ Rough Surface

Paper Tooth

A paper's surface texture, also known as its tooth, will affect how a drawing material looks. The type of tool used to draw with can determine what type of paper is needed for a most successful drawing. Some media, such as marker, require very little tooth. The marks made on a smooth textured paper with little tooth will produce smoother lines. Other media, such as charcoal or pastel, warrant a heavier tooth and will produce a rougher line. Drawing paper is usually labeled with a recommendation for which tooth works best with a specific medium. A rougher paper will usually leave voids of pigment or "white spots" due to the dips and valleys on the surface.

Paper Weight

Paper weight should be considered when choosing a surface to draw on. The term "weight" refers to the thickness or sturdiness of a paper, not the actual weight of the sheet or ream. "Lighter" papers are good for sketching or the rendering of fine details while "heavier" papers can handle water or paint without buckling or easily curling and can also handle many passes from an eraser without ripping. The heavier a paper is, the more mass that paper has per sheet. Most standard copier paper is labeled "20 lb." while popular drawing paper falls in the range of 30 lbs. to 90 lbs. This does not mean that any heavy paper is automatically of higher quality. An artist should choose a paper weight that is durable so the artwork will last—usually 50 lbs. or more depending on the medium and the project. The weight of a paper should be chosen to match the specific medium intended for use on it. There is no one paper that is perfect for all drawings, so the paper an artist chooses should depend on the kind of drawing they want to create.

Content

Paper is generally made from plant life, which contains cellulose. The type of plant a paper is made from will determine the quality of the end product. Cotton fiber offers the most durable type of drawing paper and is usually the highest quality, offering a crisp feel while allowing tones to appear richer and deeper, and handling a moderate amount of erasing. Bristol is a type of cotton fiber-based paper that is pasted together to form a thick board, known for its durability and versatility. Bristol board provides a stiff, strong surface to work on without the need for mounting. Cellulose fiber paper is the most common type of paper. It is made out of wood pulp, which is acidic, but the material can handle different marking materials and plenty of erasures. When devoting time and effort to an artwork, an artist should use acid-free, archival quality papers. Paper that is acid-free will not yellow or brown over time, resists fading, and will last much longer than papers that are not acid-free. By choosing quality paper, an artist can be assured their drawings will not deteriorate anytime soon.

Finish

There are three popular finishes that are used on papers:

Cold Press is a term used to describe paper manufactured with unheated cylinders that are used to flatten it. This process produces a slightly irregular surface that offers an irregular texture of little bumps and grooves that hold water and pigment well. Cold press papers are usually used for watercolor, pastel, and charcoal. This is the most popular paper choice used for creating texture in an image.

Hot Press is a term used to describe paper that is pressed and flattened with heated cylinders during the manufacturing process. This paper is very smooth and offers little to no texture. Hot press papers are used by artists for fine drawing, etching, watercolor, or printmaking.

Rough or *Unfinished* paper offers a coarse, textured finish that has not been smoothed with cylinders during the creation of the paper. The result of the drying process is a strong tooth that can withstand multiple layers of pigment and heavier erasing. The severity of the tooth does not usually allow for fine details when using pencil.

The subject matter and medium used can help an artist to determine what type of paper to use.

BLENDING TOOLS

The next important utensil in an artist's toolkit is a blending tool. Blending is the process of merging different shades together so that each lay down of tone flows smoothly into the next. Blending utensils can be helpful if an artist plans on combining tones to create realistic shade and shadow.

Stump

A blending stump is a great option to choose when blending one area into another. A stump is a solid, cylinder of felt paper that is tightly rolled up into a solid wand with two pointed ends. Stumps are used to blend marks made by pencil or charcoal into one another so that tones appear smooth in a drawing. These tools can work well for large areas that require detail and control. Stumps tend to be large and wide but are available in thinner forms for use in areas with more detail. Care needs to be taken when using stumps because over-blending with them can create an area of muddiness and blend fine gradations into flat tones. Also, too much use in one area can destroy the tooth of the paper surface. Stumps can become soiled with use but can be cleaned by rubbing the points with fine sandpaper to keep them tapered.

Tortillon

tortillons are another blending tool, similar to a blending stump in that they are created with rolled paper. The difference is that a tortillon forms a tight cone, having only one pointed end and is typically narrower and shorter than a stump. An artist should use the tortillon at an angle because when it is used vertically, the tip will get pushed back into itself and become blunt. This can be remedied by pushing the tip back out with a paperclip or tooth-pick. The tip of a tortillon is effective when shading in fine areas where precision and detail is important. With a tortillon, more effort is required to keep an even tone because the material is not as soft as the felt of a paper stump.

The differences between a tortillon and a blending stump can be subtle but significant. Each creates a very specific effect, so knowing how to use them properly is crucial when choosing a tool to blend with.

Chamois

A chamois is another tool used for blending tones in a drawing. It is a piece of soft, pliable, absorbent leather fabric commonly used as a rag to dry cars after they have been washed to reduce drip marks. When used in art, this soft leather square is useful when softening values and lightening areas of

pigment while blending at the same time. The dangers of using a chamois is that it can create a gloss on the surface of the paper that tends to not take more pigment if the artist desires to darken that area. When using a chamois, use a light touch and do not over-blend. The chamois can also be used for smoothing clay as well as blending charcoal and pastels.

Cotton

Cotton balls or swabs are an inexpensive option available to artists. Swabs are beneficial when blending small areas. They produce smooth gradations of tone, and they are readily available. Safety swabs made for children are a good choice because they are scratch proof and will not dig into your drawing, which also allows for easier, more consistent blending. Cotton balls or tissues are good for use on larger areas. Makeup wand applicators, paper towels, or stiff (dry and clean) paint brushes are variations of these blending tools that can be successful.

Finger Blend

The fastest and cheapest tool (free!) used for blending is your own finger. A finger can be used to blend tones into one another using a back-and-forth rubbing motion. This can be a very effective way to create a continuous gradation of tones; however, fingers have whorls and swirls, making the surface less than smooth. Also, skin produces oils that may smudge the paper or lend to inconsistent blending. Over-blending with fingers can lead to uneven chunking of tone and can embed the graphite into the paper surface. A quick wipe or two of the finger is a good rule to follow.

Other Tools

Almost anything can be used to blend tones into one another in an artwork. Some nonconventional choices I have seen in the past include homemade blending stumps of computer paper, fabric of shirt sleeves in a pinch, and even a banana peel as an experiment. I also had a student who would purposefully rub her finger on her head to pick up the natural oils from her scalp and then rub that finger onto her pencil work to blend it. It was an odd technique and offered some interesting results: the shading appeared darker and almost shiny in the areas she applied her oils to. These areas were not easy to erase and made for a very stylistic shading approach. Regardless, this student enjoyed the consequences of her invented technique and still uses it to this day.

An artist should experiment with blending tools as long as the tool doesn't have chemicals in it or other potentially damaging properties. Try a variety of tools and discover which one offers the best result for your artwork. It is a good idea to test them out before using them on an important piece of art since the specific medium and paper may affect the outcome. Potential blenders are all around, so don't be shy about using a new tool in your drawing. You might be pleasantly surprised with the outcome. With use of any blender, be aware of over-blending. Too much blending removes the line quality from an artwork and has the potential to make an artwork muddy and less dynamic.

ERASERS

Erasers are a tool essential to the drawing process. They remove misplaced marks or mistakes from an artwork but can also be used to draw and create form with.

Common Eraser

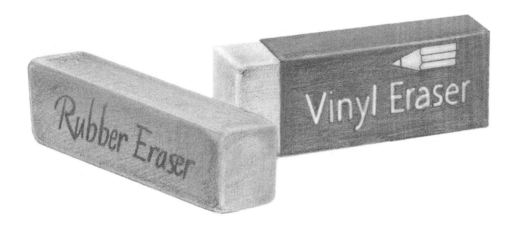

Conventional block erasers have a rubbery consistency and are designed to remove marks from paper. While most erasers are constructed to remove pencil marks, there are erasers created for the purpose of removing type-writer marks and some inks. Typical pencil erasers are usually light pink in color and come in wide, slender blocks or are found permanently attached to the ends of pencils; however, they can be a variety of shapes, sizes, and colors. Less expensive erasers are made from synthetic rubber while more expensive or specialized erasers are vinyl, plastic, or gum-like materials. When drawing with pencil, the common eraser is good at removing all but the darkest pencil marks completely. There are a few drawbacks to relying solely on this type of eraser when creating art. The clunky form of the eraser causes a lack of precision when removing marks, which makes it difficult to erase small marks with complete accuracy. Also, small bits or eraser debris are often left behind. When these bits are brushed away, fine shading can smear or smudge in unrealistic ways. The common rubber eraser is a neces-sary tool for an artist to have; however, its use is limited to removing large marks.

Kneaded Eraser

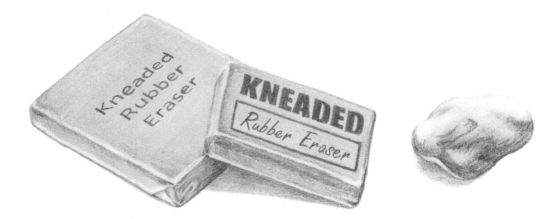

Unlike the common vinyl or rubber pink erasers, kneaded rubber erasers are more pliable and can be stretched, molded, and kneaded (hence the name) into any shape. It erases cleanly, doesn't leave dust behind, and picks up areas of pigment that are too dark. It's excellent for removing pencil, chalk, charcoal, and pastel marks or creating highlights. A typical kneaded eraser comes in a plastic wrapper, is light gray in color, and is often mistaken for a piece of clay. It acts like a piece of clay as well, bending or stretching as needed to erase specific portions of an artwork, including very small areas. This eraser should be stretched and folded when it comes out of the package in order to make it softer and easier to manipulate. Once broken in, these erasers can be used in a general back-and-forth motion but are more effective when they are simply pressed onto the pigment and then lifted off. The residue is transferred to the eraser and the marks on the paper will be noticeably lighter. The eraser will absorb the pigment and clean itself when it is stretched out a few times. Eventually, the eraser will absorb so much pigment that it won't self-clean anymore and a new eraser should be purchased. This tool is most efficient when the "press and lift" method is used. It can also be pinched into a fine tip and then swiped onto shaded areas using light strokes to add highlights. In this case, the eraser is used like a pencil except instead of adding a mark, pigment is taken away. Instead of using the eraser to correct a mistake, it is actually used to draw with. Since this eraser can be molded into any shape, it is very versatile in terms of the variety of marks it can make. This eraser is a valuable tool to every artist who draws. The only drawback to using this type of eraser is that it cannot be used as successfully as the common rubber eraser when removing marks completely. A kneaded eraser is not as strong and stiff as a common block eraser, so it is better for making more subtle changes in the tones of a drawing.

Eraser Stick

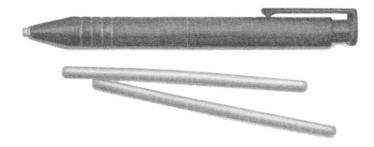

Stick-style erasers are a more precise alternative to conventional block erasers. They come in a long, cylindrical shape encased in a protective plastic case, often with a convenient clip on the side. Many stick erasers can be advanced or retracted as needed. The rubber is soft, pliable, and won't tear the paper. The best stick erasers are small in diameter and result in clean and precise mark removal, as the wider versions do not allow for thin erasure lines. Refills are available for some brands of eraser stick even though replacements are not frequently required, as these erasers last a while. This tool is best utilized when putting the finishing touches on an artwork. Drawbacks to using this tool is the temptation to use it too early. Creating highlights and light lines on an artwork too soon can cause an artist to focus on small details before the composition and first lay down of shade is complete. Also, the stick eraser should only be used on small areas.

The variety of erasers available to artists allow for beautiful contrast, crisp highlights, and gradated values that help to make an artwork appear more realistic.

The supplies an artist chooses to create with is a personal choice. Using a variety of different supplies and experimenting with them is the best way to decide what is right for you and your desired result. With use and experimentation, an artist will unconsciously decide upon a favorite brand or grade of pencil to use over and over again while the rest may get used once and then forgotten in the junk drawer.

CHAPTER TWO
PUTTING THE TOOLS TO USE

Know:
• A value scale consists of a series of spaces that are filled with tints of one color, starting with white or the lightest tint on one end and then gradually changing into the darkest shade on the other end.
• Value is one of the seven elements of art.

Understand:
• A value scale helps an artist to become familiar with the variety of hues that exist in a work.
• Different pencil grades and pressure are used to create a variety of tones in an artwork.

Do:
Create a value scale representing at least five different tones from light to dark by using a choice of grade B pencils and varying the pressure of those pencils.

Now that you have an idea of the basic tools used, let's get started! In this first lesson, we'll discuss using different pencil pressures to create a variety of tones in an artwork, how to create a value scale of five tones to use for reference when shading an artwork, and how to use simple shading effectively on an object using just five tones.

Shading is one of the easiest ways to add depth, contrast, character, and movement to your drawings. One of the best ways to become familiar with value is to draw a value scale. A value scale, also known as a gray scale, is a helpful tool to use when shading an artwork that consists of a series of spaces that are filled with tints and shades of one color, starting with white or the lightest tint on one end and then gradually changing into the darkest shade or black on the other end. There could be hundreds of different shades in between the lightest and darkest value; however, the value scale that we are going to make is just a small representation of the tones that can be created with pencil. To begin, create a grid of five equally spaced blocks or make a copy of the empty grid shown below. These empty blocks are going to serve as spaces we will fill in to create our value scale. Number them one through five.

1	2	3	4	5

We are going to use a variety of pencils and pencil pressures to fill in each block to create this value scale. It can be helpful to start putting down tone from the darkest to the lightest; however, there is no right or wrong way to begin. I like to shade the darkest block on the far right-hand side first (box number 5), using an 8B pencil, one of the darkest and softest pencils. This allows me to see how dark I can get the darkest shade while each subsequent placement of tone will become lighter and lighter. A simple back-and-forth motion should be used when filling out each box to create an even, dark tone. Another way to fill the space could be a series of small, scribble-like marks called scumbling. Scumbling uses layers of small scribbled marks to build up value and texture.

Example of simple back-and-forth shading on the left and scumbling on the right.

The goal for box number 5 is to get a deep, rich tone for the darkest area of the value scale. This does not mean that the artist should press so hard that a black tone is created. The pencil pressure should be even and hard enough to make a dark mark, but not so hard as to break the tip of the pencil or rip the paper. The tone should not be as dark as you can possibly make it for this exercise, just dark enough to be created comfortably. This might require a few passes over the same area to build up the dark tone. Do whatever is necessary to make box number 5 a solid, dark block of tone. This block will eventually represent the darkest areas of shade and shadow in an artwork.

With this same pencil, move to the next square (box number 4). You can use the same 8B pencil, just use less pressure to leave a deep gray tone. The gray created in box 4 should be dark, but not as dark as the tone seen in box 5.

For box 3, the 8B pencil can be utilized again with lighter pressure or the 6B pencil can be used to attain a medium gray tone. This tone should be lighter than the tone created in box 4.

Finally, even less pressure (or the 4B pencil) can be used to shade in box number 2 to achieve the lightest gray tone, a shade that is just a bit darker that the white seen in box number 1. Box 1 will stay white to indicate the lightest tone of the value scale. From left to right, these boxes should represent a gradual change from light to dark. These five tones are just a small representation of the many shades that can be created with a pencil, but we only need five tones for our first exercise.

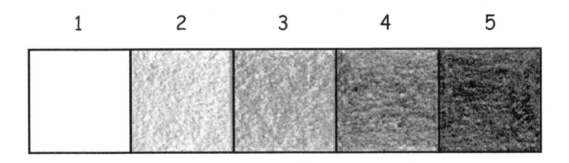

Here is an example of a completed value scale showing five tones. Several different pencils were used to create this value scale. If you prefer, you can use one single pencil with different pencil pressures to achieve similar results.

Keep this value scale nearby, as we will refer to it often through the following shading exercise.

CHAPTER THREE
Five-Toned Drawing Exercise

Know:
- Referring to a value scale when shading can help to determine which tones should be used in an artwork.
- Numbering values on a scale and in your art can help to make those values more recognizable.

Understand:
- Comparing values can help an artist to recognize subtle changes in tone.
- There are a variety to techniques that can be used to transfer a drawing from one paper to another.
- Creating a "paint-by-numbers" framework is helpful when determining the placement of multiple shades of tone.
- Seeing and replicating shapes and areas of tone on an object as opposed to recognizable features can help to make drawing and shading easier.
- The difference between drawing what you see and what you think you see is crucial when creating a likeness.

Do:
- Observe and create areas of differing tone in an artwork.
- Practice shading a portrait using only five hues.
- Create a tonal outline of a simplified image or portrait by drawing lines around areas of shade, not features.
- Compare values and practice shading an artwork by observing a value scale to replicate five major tones spanning from light to dark.

Next, we're going to use this value scale to create a drawing using just five tones. This exercise is all about comparing values, which trains your eye to see subtle changes in tone. It is also a great way to practice shading an object using only five hues. Without a value scale to refer to, it can be difficult to determine how much darker one value should be than the previous one,

so keep your value scale close by. We are going to apply the basic five-tone value scale to a portrait that has been simplified into a "paint-by-numbers" grid.

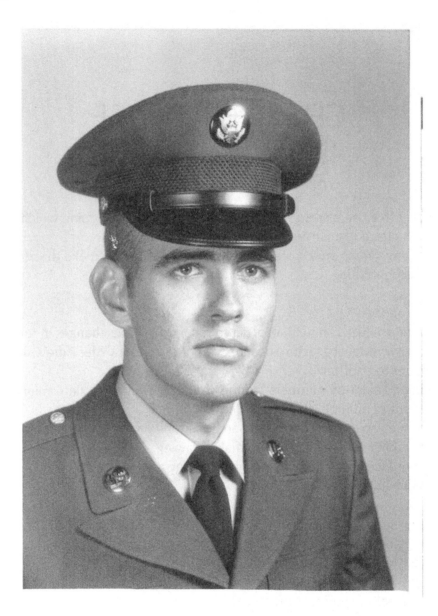

The subject matter for this lesson is an image of my dad. This photo I found is perfect to use for this lesson because the tones are crisp and clear while showing contrast between the dark and light tones. To begin this drawing, I need an outline to work with. This outline should not be a typical line art drawing of the eyes, nose, mouth, etc., but rather lines that indicate where one tone ends and another begins. The easiest way to break down this image into a series of tones is to scan the image into a photo editing program

on a computer, simplify it into five tones, and then transfer the details onto drawing paper. This can also be done on a photocopier on the "photo" setting, but the areas separating the lines for shadow will not be as crisp and clear.

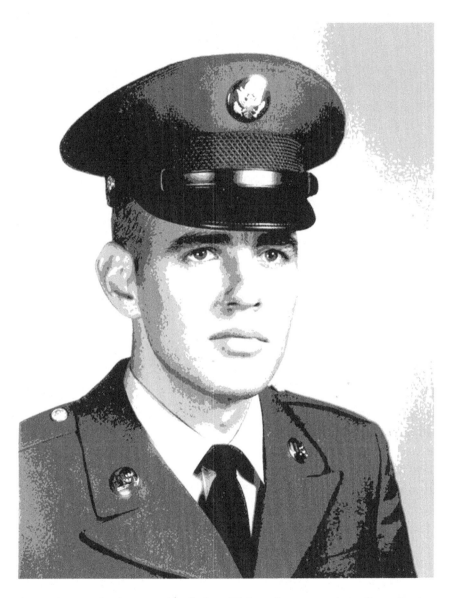

The above image is the result of simplifying the tones into five shades using a photo editing program. If you do not have a photo editing program available for this exercise, I would recommend using the pre-drawn outline provided in this book instead of your own image if this is your first try at this type of artwork. It takes a trained eye to be able to separate a black-and-white image into five shades without the assistance of specialized art-making computer software. Eventually, you may want to try this technique with

an image of your own. If you choose to use your own image, see the end of the chapter for specific instructions on how to make your own photo into a simplified five-toned image.

Using a copy or printout of the five-toned image (not the actual photo), transfer an outline of each visible tone onto your drawing paper. If you are using your own image, try using one of the transfer processes described below. If using the portrait of my dad for this exercise, you may wish to skip directly to the shading process by using a copy of the blank "dad outline" seen later in the chapter.

Transferring an Image

Getting your image onto your drawing paper is easier than you think! Sometimes an artist believes that they have created a perfect sketch or need an exact copy of their work and do not want to have to redraw it onto their final paper or canvas. There are several solutions to transferring an image. All of the following methods are useful; however, I recommend the charcoal transfer process.

One way to transfer a drawing is to prick the lines of the composition with tiny holes then *pounce* on it with charcoal (powdered charcoal in cloth), which then goes through the holes and transfers the design to another paper or canvas. This was a technique used by the old masters. It is a messy yet effective way to get a copy of your drawing onto another surface.

The *grid method* is another way to reproduce or enlarge an image. It involves drawing a grid over a reference photo to divide it into small increments, and then drawing a grid of equal ratio on the paper, canvas, etc. that the artist wants the work to be transferred to. The artist will then draw the image onto the paper, canvas, etc. focusing on one square at a time until the entire image has been transferred. This is an inexpensive technique that exercises observation skills, but it can be time consuming.

A *projector* is another way to create an accurate line drawing from an image. It is a machine that enables an artist to project an image onto another surface. The image can be made different sizes, which offers control of the size and composition.

Yet another way to get an image from one paper to another is to use *transfer paper*. This works like old fashioned carbon paper except it uses graphite and not carbon. An artist will tape a piece of transfer paper ("messy" side down and "clean" side up) to the canvas or paper they want to transfer their

art to. A copy of the reference photo is positioned on top of the transfer paper and taped down. A pencil or other blunt instrument is used to trace over the lines of the reference image and are then transferred to the canvas or paper.

I recommend the *charcoal* transfer process. This method doesn't require extra purchases and uses the least amount of layers to get the job done. Start by filling in the back of the reference image with charcoal. That means you want to take the print of your photo and flip it over so the print side is facing the table and the blank backside of the paper is facing upward. Take a piece of charcoal or a dark smudgy pencil and fill in the back of the paper using a back-and-forth motion, careful to not leave any areas of white.

You can fill in the entire backside of the paper or just go over the area that needs to be transferred. Note: If you are using charcoal, your work area will get a little bit dusty from the refuse created by the charcoal. For safety reasons, don't blow the dust into the air. It is tempting to blow on your paper to clean it; however, this will put charcoal particles into the air for people to breathe in. This is especially important not to do if a whole class is doing this project. Also, be wary of resting your hand on the charcoal-filled area–it will definitely get on your skin, which will then likely smudge on to unwanted areas of the artwork (or you). This is not so much a health hazard as it is messy.

Once the charcoal coloring is done, carefully take the paper and flip it over so the charcoal side is facing the drawing paper. Do not slide the paper around to see where it fits best at this point because the charcoal will smear all over the drawing paper. Instead, gently place it and pick it up to reposition it if need be. Once it is placed to your liking, tape it down to the drawing paper on one side using a few pieces of tape spread out from one another (i.e., tape the left edge at the top and the bottom). This will allow you to flip the photo image over like a page in a book so you can see your traced image beneath. If you put tape on every side (i.e., left, right, top, and bottom), you won't be able to lift the paper and check your work.

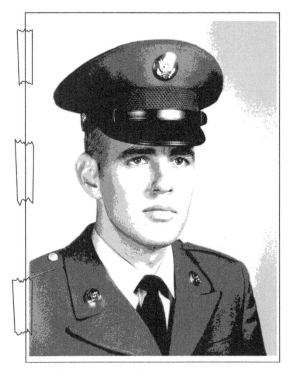

Tip: This tape will eventually be removed, so make sure the tape isn't super sticky. If it is, it may rip or fray the good drawing paper when you eventually remove it. I like to stick the pieces of tape to my pants or a sweater a few times before I stick it down on the paper so it gets a little bit linty. This makes the tape just sticky enough to adhere to the paper but not so sticky that it will tear or peel some of the paper off once you try to remove it. This is a great trick to use when taping down things that will eventually be removed. If available, use an archival artist tape. This is ideal since it is acid-free and removes easily without leaving behind any residue.

Once the printout is taped down, trace or go over the edges of every single different tone that you see. Do not draw lines around the eyes, nose, mouth, etc. if those lines are not there. Sometimes our brains want to "fill in the blanks" and make us draw what we think we see, not what we actually see. This is where it is important to draw the edges of each tone as opposed to facial features.

There are only five tones here, so differentiating which tone is which should not be that difficult, but it will be time consuming, especially near the eyes. Notice that the edges of each tone may appear as a jagged edge on the printout. There probably will not be a clean line between each tone. The best way to handle this is to simplify the line, making it straighter than it appears or smoothing out the miniscule jagged edges. This makes the outlines easier to trace and the results actually look better.

I began by outlining the darkest areas first, then outlined all of the second darkest areas, then the third darkest followed by the fourth darkest tone. White areas do not need to be outlined. The outlining process can get a little bit tricky around the eye area because there are many small details to capture. Take your time with this. The eyes are important when trying to capture the personality and character of the person that you are trying to draw. Adding these details during the transfer process will also make the shading process easier. Feel free to check on your tracing from time to time during this process by carefully lifting the top paper. Once the transfer looks complete (and you have double checked and tripled checked that all tones have been outlined), remove the printout from the drawing paper to reveal a detailed outline of all the shades. Now, you have completed the drawing, so all you need to do next is concentrate on putting tone inside the lines.

Once you remove the printout from the drawing paper, you should have an image similar to the one on the following page. Don't throw away the printout! We are going to need it for reference. Tip: To prevent getting dirty with charcoal residue every time you touch it, take a clean piece of paper and tape it to the "dirty" side to cover the charcoal. That way when you pick it up, you won't get charcoal reside all over your hands. Set this tracing aside for the moment.

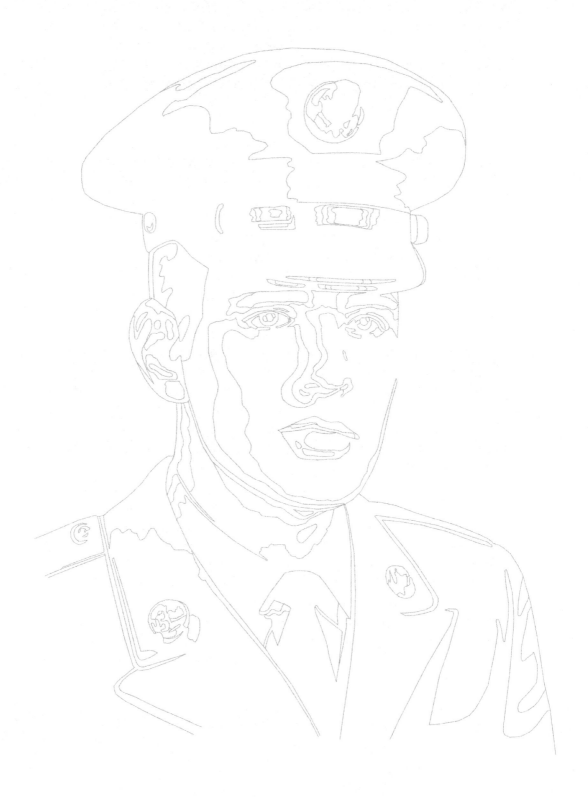

28

The drawing you now have is a simple outline indicating where one tone ends and another begins. It will look very odd and may not even be recognizable as your original object. Do not be concerned; it should look strange because there is no shading on it, which makes it look empty and incomplete. Eventually, it will all be filled in with different tones and will look very different. Consider this outline to be just a skeleton for our final drawing.

The next step of this process is to create an easy-to-follow "paint-by-numbers" map. Painting by numbers is a system where a picture is divided into shapes, each marked with a number that corresponds to a particular color or value. An artist fills in each shape and ultimately the shapes come together to form a finished artwork. Match up the five shades on the printout to the five shades on your value scale. The darkest tone on the photo print should be similar to box number 5 of your value scale. With a pencil, write directly on the printout and label each of the darkest areas with a number 5. The second darkest tones will be labeled with a number 4. Label all of the middle gray tones with a number 3 and the lightest gray tones should be labeled with a number 2. The white areas on the printout will be labelled with the number 1.

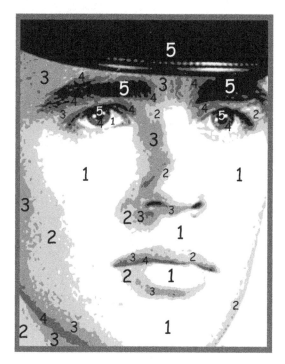

Once all of your areas are labeled, go back and double check the tones near the eyes, as there may be some small areas you may have missed. The more tones you label now, the easier it's going to be when the shading process

begins. This process is a bit time consuming but stick with it! The effort put into labeling the tones now is essential to a successful outcome.

This numbered printout will serve as a "cheat sheet" we will refer to when adding value scale tones to the outline drawing. Keep this printout handy, as you will need to look at it from time to time when shading in your artwork.

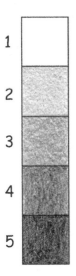 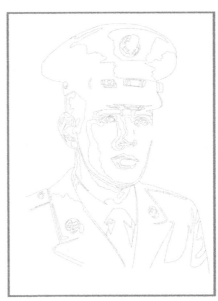 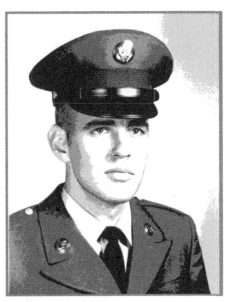

Above I have laid out the value scale, my artwork, and the printout to refer to.

Now we will begin the shading process. You should have your value scale and the printout labeled with tone numbers nearby. One thing to keep aware of as you are shading the portrait is that this is just a transfer. The charcoal lines, although they appear dark, can be easily smudged or erased. Tip: Be careful of resting your hand on your artwork because the lines will definitely smudge or even disappear. This can be more than a little frustrating, so avoid leaning on your work as you shade or go over the outline again with a lighter, firmer "H" pencil. An extra step, but well worth it!

Regardless of how careful you are, there will be some smudges here and there due to the nature of the charcoal transfer. This is where the kneaded eraser comes in very handy. The eraser comes in a flat, rectangular, or square package. You may need to break it in by stretching it and folding it in upon itself a few times until it softens and can be more easily manipulated. A lot of my students think that the eraser is that piece of clay and wonder why I am dabbing at my paper with it. I tell them that it's not clay, it's in eraser, and it's amazing! This is a great tool that every artist should have in their

arsenal of materials. These erasers are fun, easy to use, and great for picking up pigment. Unlike the more common rubber erasers, you don't necessarily need to rub in a back-and-forth motion to remove a mark, leaving eraser residue behind. Using a gentle "press and lift" motion, you can pick up a lot of unwanted pigment. If needed, the eraser can be manipulated or stretched into different shapes. This is especially helpful when removing pigment in small areas. When using the "press and lift" technique, the kneaded eraser probably won't take all the charcoal off of the page. In areas of extreme darkness that need to be removed, sometimes a block eraser needs to be used. For now, we just want to remove the fingerprints and smudges so the kneaded eraser should suffice. If we were removing large areas of charcoal, the eraser would need to be cleaned because it does tend to collect a lot of the pigment. All you need to do is stretch it apart and roll it in on itself and the dirty area will disappear.

To begin shading, I like to start with the darkest area first, just like with the value scale. Look at the labeled printout and locate all of the areas numbered with a 5. Using an 8B pencil, fill in all the areas on your outline drawing that should be 5s. These are the darkest, richest tones. Press as hard as you can without breaking the tip of the pencil and fill in all of the areas that should be 5s with a neat, uniform, back-and-forth motion. Concentrate on using an even pencil pressure to get a smooth lay down of tone. The goal here is to eventually have five different separations of tone that will form shade. For the sake of consistency, I've filled in all of the 5s that I saw first, without skipping around to any other numbers until all of the 5s were complete. Double check to make sure you have captured all of the 5s in the eye area.

Tip: Fill tone right up to and slightly over the line; don't leave any white space between tones for an even look.

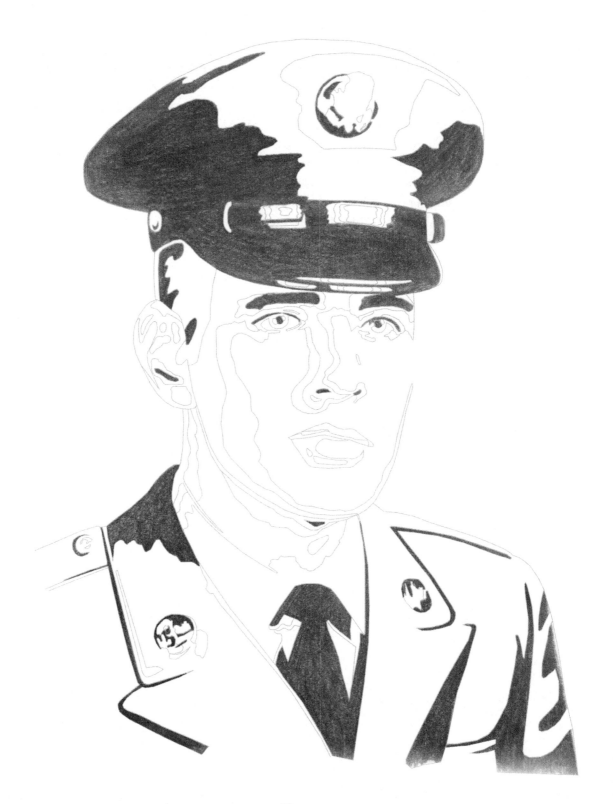

Once all of the 5s have been filled in on the drawing, observe where the number 4s are labeled on the printout. Fill those areas in on the drawing with a tone that matches the one created for box number 4 on your value scale. The 4s should be slightly lighter than the 5s, enough so that there is a distinguishable difference between them. You can use your 8B pencil with less pencil pressure or the 6B pencil using the same pressure to achieve this tone.

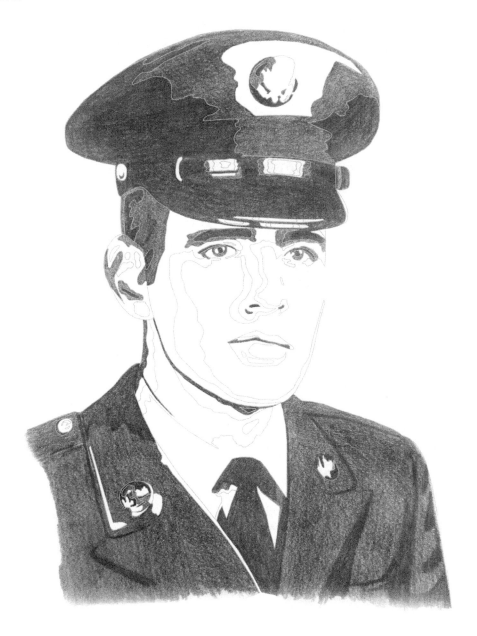

At this time, there should be a significant amount of tone placed on the drawing. Take care to not smudge these tones into one another (on purpose or by accident). It is tiresome to keep your wrist raised off the paper during the shading process, so it may be helpful to lay down a blank piece of paper underneath the padding of your hand that touches the drawing to use as a barrier.

Once the 4s are complete, fill in all of the areas marked with a 3. The 3s should be lighter than the 4s and match the 3 on your value scale. You may wish to use the same 6B pencil and use a lighter pressure or move to a 5B or 4B pencil.

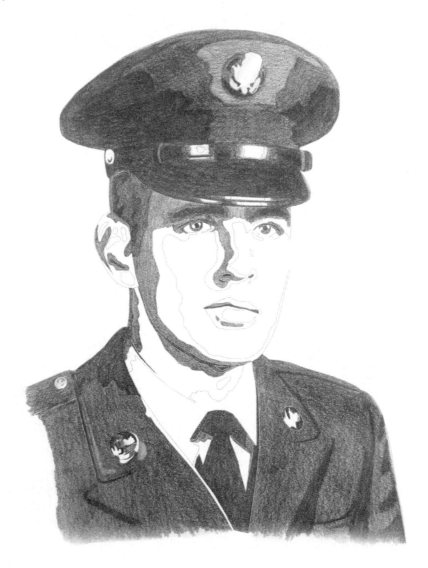

Finally, fill in all of the areas marked with a 2. This is the lightest of the gray tones and should match the number 2 box on your value scale. The number 1s are white and do not need to be shaded in.

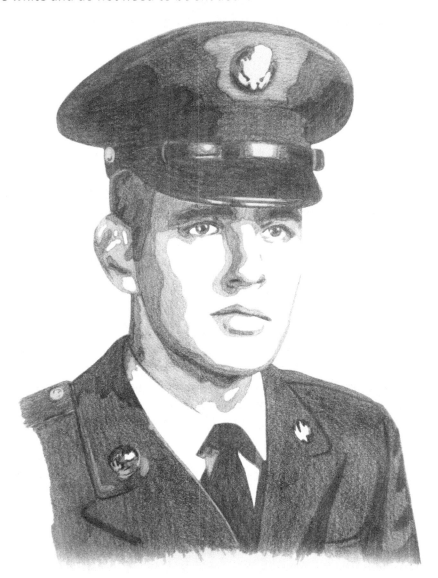

The completed image should look something like the one above. These shades of gray make up the mood, composition, and the believability of a drawing, creating the illusion of depth and three-dimensionality. Once the "filling-in" of tone process is complete, you will have a beautifully finished, shaded drawing. Try to avoid blending these tones together since a crisp beginning and ending to every tone is the goal for this lesson. Being aware of changes in tone and practicing finding and creating tones will help an artist to create better shading, regardless of the subject matter.

How to use Photoshop to create a five-toned image: If you wish to use your own image, you will need photo editing software to simplify your photo. Choose a high-contrast picture that has rich, dark tones and crisp, light tones. I scanned my photo into Photoshop and placed it into a document that was 8.5 x 11. Select your image then go to Filter > Adjustments > Posterize. Move the pop-up slider to five levels and click OK. Save your work and print a copy to use. Posterizing is a quick and easy way to simplify tones.

How to use Microsoft Word to create a five-toned image: Go to the "Insert" tab and click "Picture" from the menu. Double click on the picture until the "Picture Tools" tab appears at the top of the screen. Click on the "Corrections" tab and go to the bottom of that menu to "Picture Corrections Options." This will open a pop-up menu. Change the contrast slider to read "100%" then click on "Picture Color." Change the saturation to read "100%." Change the temperature to 7,000. Recolor the image to grayscale (second option under presets). Adjust the other sliders (except sharpness) as needed until the image has five tones.

Examples, Questions, and Comments

The following examples, questions, and comments were submitted by students and discuss common issues faced by artists and real solutions to address them. As you will see, some students chose the image in the book to practice with while others chose their own images. You will see a variety of styles and skills, making each piece unique and beautiful. As you view these works, do not compare your work to the art of others. Your original approach, stroke, and style is what makes a work one-of-a-kind and special.

Comment: While I was transferring my outline for the five tones, I found it very difficult to mark the shades in small areas. They were clear on the printed image, but my tracing lines ended up being much thicker and covered up some of the fine detail I needed.

Reply: Those small areas can be difficult to replicate and may not be reproduced exactly how you see them when using the charcoal transfer technique. There are a few things you can do to get a better copy. Make sure the pencil you are using to outline the tone with is sharp when you get to areas of fine detail. You can also simplify what you see. There are a lot of tiny slivers of tone change seen especially in the eyes, which can be simplified. They will still look good as long as you take care to leave in the white highlighted areas and any pupil/iris tone changes. Finally, if you are unable to trace the details during the charcoal transfer process, you can always observe your printout

image and carefully draw them in with a sharpened pencil later. Oftentimes, these small areas may be too small to be labeled with a tone number when creating your "paint-by-numbers" grid; therefore, it is necessary to have the reference image in front of you at all times to look at.

Comment: I had some trouble differentiating between levels 3 and 4 on my value scale using the pencils you suggested.

Reply: If you find that the pencil grade I prefer for a specific task is not sufficient, definitely change to a pencil that will fit your needs. The marks that pencils make have to do with brand and pressure. Use more or less pressure to re-create the proper tone, or change pencils to a softer or harder graphite. The pencils I use are just a suggestion that works for me. You need to explore and find out what works for you.

Question: Do you have any tips for transferring? What I mean is, when I transferred my image, I had to erase a lot of extra charcoal dust. I don't think I put that much on, but I've never used it before.

Reply: Yes! Charcoal is a bit messy, but it is fast. You can use pencil, which is virtually dust free as compared to charcoal; the only drawback is that it takes more time to fill the paper. Another method is to use a light box or a window to trace. This method allows you to simply trace without adding layers of pigment. Place your outlined print-out on the window or light box and then put the paper you want to draw it onto over it. You should be able to see where to draw your lines if the drawing paper is not too thick.

Question: Have you ever used an ebony pencil for your darkest darks?

Answer: Ebony pencils are fun to work with and produce thick, dark lines that are easily blended. The jet-black graphite can help to create beautiful contrast in an artwork; however, I would not suggest using an ebony pencil in your artwork for only certain areas. If an ebony pencil is used for only the darkest darks, it will create a deep, dark tone that doesn't quite match the rest of your artwork. Staying in the same "family" of pencils for an entire drawing can offer the best success. If you want to try shading with an ebony pencil, use that ebony pencil throughout the entire artwork. You can create different tones by varying pressure and adding layers of tone.

Comment: The most difficult part of shading is the eyes. I enjoyed doing it, even if it didn't turn out the best.

Reply: Eyes are tough because the detail areas are very small. Observe your reference image often to make sure you didn't miss anything crucial.

Question: How do I figure out which tones go where?

Reply: Keep that value scale handy and place it next to shades in your drawing if need be to match the tones. Another tip is to squint! By squinting your eyes, the image becomes more simplified into areas of chunky shadows that are easier to pinpoint.

Question: My artwork looks flat and two-dimensional. Any suggestions?

Reply: Make sure you are filling in your sections of tone right up to and slightly over the lines that separate the tones. Any voids between changes in tone will now have a complete look. The type of paper you use can also help. Printer paper can leave artwork looking flat while drawing papers offer more texture to create interest.

Question: I don't have a computer program that will allow me to create a five-toned image. What should I do?

Reply: Check out your local library! They offer much more than books, including computers for your use and often technical experts to help you use them. While you're waiting to get prints to use for shading, try the sphere-shading lesson or the tree-drawing tutorial. Those lessons show simple techniques to quickly draw an item so you can concentrate on the shading. If using your own image is impossible, use the image provided in the book that is already broken down into five tones. If all else fails, draw something of your own. The "How to Draw Cool Stuff" series can help you with ideas and get those creative thoughts flowing!

Question: Do I have to use just five shades? I find it difficult to limit myself.

Reply: It can be difficult to limit your palette of tones, but it is a great exercise in practicing pencil tone and pressure. Try to keep your tone variety between four and six, especially if you have not done an exercise like this before. Definitely use your value scale as a reference!

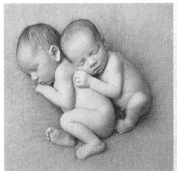

Photo by Elizabeth Jayne *Transferred into five tones* *Artwork by Pamela Dowie*[1]

1 *Example of the process used by students when creating an artwork using the 5-toned process.*

Artwork by Pamela Dowie

Question: I made a value scale, but I found it hard to use only five tones during this exercise. Did I include too many objects?

Reply: The number of objects won't change the tones that will be needed in order to create shade in a drawing. You can have one or one hundred objects in an image, and the information needed to create it realistically will be the same: location of highlights, midtones, and shadows.

Shading with a simplified value scale can be considered not only a drawing exercise but also an important tool when trying to learn how to shade. Value scales can have as few or as many ranges of tone as you wish. There are thousands of possible tones, but we only need to replicate a few for this exercise. I've been demonstrating how to draw a value scale consisting of five different values, but you can certainly change that. It does become more difficult to use a value scale when drawing if there are multiple ranges of tone. This is why I recommend starting with a value scale consisting of five values. This will help to make recognizing tones easier and will give the artist the confidence needed before moving on to more difficult drawings. Once you create an accurate value scale, it can be used to discover values in any object you are drawing and shading. I cannot tell if the drawing you have shown me is successful in its use of tone since I have not seen the original; however, the modeling of form and cast shadows do help to make the drawing appear realistic. If you are concerned about making your shade and shadow more realistic in terms of value, you should try and follow a five- or seven-toned value scale. Try holding your value scale in front of the actual subject matter you are drawing and choose a value on the scale that best represents that tone. Match that same tone to the same area in your drawing. This method can be time intensive but a very accurate way to learn how to shade. Also, drawing larger can help you to identify areas of tone easier.

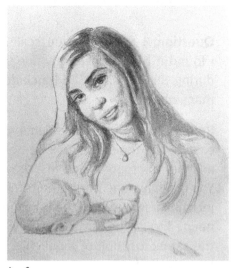

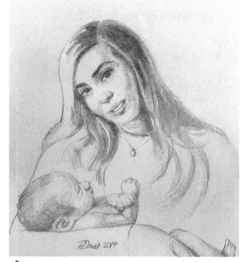

before after

This beautiful composition was created by a student[2] who wanted to make a portrait of her niece holding a baby. I suggested that the baby needed a bit more contrast since my immediate focus went to the attention of detail placed on the woman; the baby is not as prominent, as it lacks the contrasting values that the woman has. Solving this shading issue can be difficult since babies don't usually have much contrast on their faces. One solution would be to scale back on the contrast on the woman if adding more to the baby is too daunting. Another solution would be to add deeper tone to the baby so the artwork as a whole appears more balanced.

After adjusting a few areas of the artwork, the final result is subtle, yet more uniform, creating a balanced and charming study. I told the student that if it was given to the niece as a gift, she would surely cry with tears of happiness! The student stated, "I was thinking of keeping the focus on my niece but had wondered if the baby needed more work. I think now it is much better with a little more shading on the baby. I am really pleased with your lesson, and I will be using this technique a lot. Thank you!"

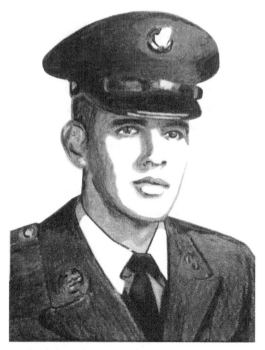 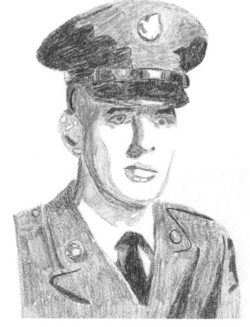

Artwork by Jay Costello *Artwork by Daniel Warren*

The above artworks are good examples of shading a portrait using only five tones. The artists have created a likeness and used five shades of gray successfully. The outlining of features, visible especially around the collar and nostrils of the artwork on the left and the outline of the eye seen in the artwork on the right, could be omitted to make the work appear even more realistic. It is not necessary to draw lines to identify these facial features because subtle shadows already define them. It is difficult to change your way of thinking from defining what we know is a nose or an eye to a series of shades. It can be difficult to not outline features, but it is important not to. A good rule of thumb when drawing from life (or photos) is to draw what you see, not what you think you see. As an image becomes more detailed with shading, the original outlines should become blended within the shades. Objects or features in real life are not outlined; therefore, they should not be outlined when shading realistically.

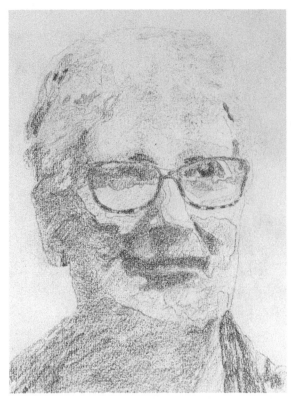

Artwork by Anita de Rooij

"This was one of the first things I made. I never drew before and love your explanations about shadows. I learned a lot, which helped to give me the courage to do more drawings."

"Catherine shows you how to look at the light and gradations of shade in the original photo and very clearly outlines how to reproduce them with the pencils. My greatest issue was that I couldn't work out how to reverse the original photo and ended up doing the whole thing in mirror image, so it turned out to be quite a challenge! I loved using this very clever and effective method. I am very much a beginner artist and never imagined I could achieve such a good likeness to my great-uncle James Winning (incidentally, he was killed in Gallipoli, Turkey, during World War I just a few months after this photo was taken in 1915)."

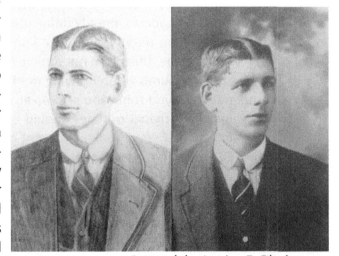

Artwork by Louise E. Bladen

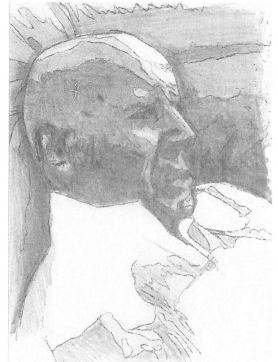

Artwork by Nellisa Noordijk

"For this lesson, I started by making a photo of my dad in one of his 'Alzheimer' moments. According Catherine's instructions, I manipulated the picture on the computer to five shades and then tried to draw it with the grid method. At the beginning, I thought it wouldn't work out because it felt like I was drawing spots instead of actual facial features, but when I finished, it all came together! This method has taught me to look differently at a subject. I see segments with tonal differences now instead of a solid shape. This method helps me to create depth, and it is a great way to simplify a difficult scene. This allows me to work faster, which is necessary when doing plein air sketching."

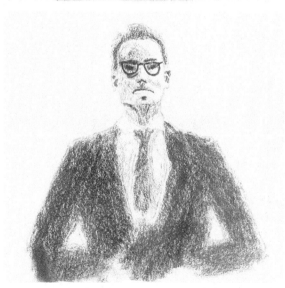

Artwork by Tamara Eden

"The five-tone process really helped train my eye to see different layers of shading."

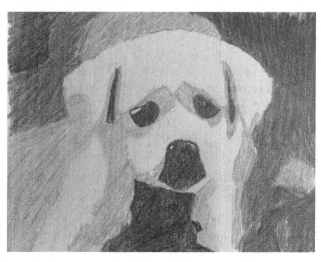

Artwork by Whitney Krug (age twelve)

Question: This is my five-tone drawing. I chose to do a puppy instead of the suggested image. Could you please tell me what I could do to improve it?

Reply: This is a great simplified image, perfect for the purpose of this activity. I haven't seen the image you were working from so I cannot really tell you if it's lacking anything; however, I'm thinking that there could be more midtones on the face area and body. I see sharp contrast from dark to light, which is very striking. Some more subtle tones are needed for detail. That being stated, sometimes the original image does not translate well into five tones. I have used only four with some images when teaching this lesson and as many as eight. Playing with the image on the computer is a great way to "sketch" your artwork before actually attempting to create it. This process offers a sneak peek at what your final artwork can look like.

Question: Sometimes the darkest value looks like a line almost. Is it best to combine this area into the next value? My object was small so perhaps not right for the exercise.

Reply: The object you are drawing can be as small or as large as you want; however, it should be large enough for you to see detail. It is only the representation of the image (your drawing) that needs to large enough for you to re-create successfully. This can be done large or small, depending on the tools you are using. Some people excel at drawing very tiny, detailed works of art while others are more comfortable drawing on a larger scale. That being said, if the drawing is so small that the deepest shadows are drawn with a thick, dominant line to represent the edge of something, the appearance of depth and dimension can disappear. The idea of this type of line is similar

to outlining areas of an object. This is not useful for realism. When an artist follows the shape of an object to the edge, the area behind that object (even if it is another part of the same object) is represented. In reality, objects are not outlined, we simply see the edge of one object next to the background that is behind it. Parts of this may appear to be a line, but this line generally does not go all the way around a shape to "outline" it. Definitely try blending tones to create a gradient, which will appear to be much subtler. When blending tones, it is tricky to point to a specific spot in the artwork to indicate where it starts getting darker or lighter because blending gives the illusion of shade that constantly gets just a little bit darker or lighter, indicating there is no place where shade just stops or starts.

Comments:

"I found this to be an excellent way of looking at a value scale. You offer some great tips on converting the photo to a five-toned drawing that have helped me with my other artworks."

"I had trouble limiting myself to five shades. Keeping the value scale next to my work in progress was essential since I kept wanting to add more shades than what was needed for this exercise."

"Thank you for the tutorial on the use of values and simplifying tone in an image. I really like this method, as it exaggerates the highlights and shadows, making it easier to determine where to put each tone."

"In my five-tone drawing, I found the eyes and the ear to be the hardest. I had to really observe the subject to see where those small differences in shades were. This part was the most time consuming, but I am glad I did it. I learned that observation is key when shading realistically."

"I loved the tip for using the posterize option to break down a photograph into only five shades. What a great tip if your eye needs help seeing the layers of shading!"

"I've always been interested in drawing, and my favorite subject has always been people's faces. More specifically, I've always wanted to be able to capture people's likeness and their moods. Instead of focusing on details, this lesson taught me how to simplify the face using basic shapes, being mindful of light and shadows and capturing the unique bone structure of the subject, before zeroing in on the features. It is this new mode of thinking that has helped me to improve my freehand drawing exponentially. Now I have more confidence in my ability to draw because I am no longer limited to precision tools. While there are still some poses that I find challenging, and there are times when I don't capture the likeness at the first attempt, I no longer get

discouraged like I did before because I now have the knowledge to under-
stand where I am making mistakes and what I can do to make corrections in
future attempts."—Johanne Climaco @johanneclimaco

"I'm really enjoying this lesson so far. I can see how practicing with the
five-value shading process can help me with future drawings, even drawings
that require more than five tones."

"Taking this class has helped me to refine my understanding of light and
shadows. This better understanding has made my drawings appear more
realistic." —Dan Warren

CHAPTER FOUR
Cross-Contour Drawing

Know:
- Line art emphasizes form and outline over shading and texture.
- Cross-contour lines describe the inside of an object using lines that follow the direction and shape of an object's inner details.

Understand:
- The way an artist holds their pencil, and the pressure they use, causes different marks to be made.
- Tracing along the inside details of an object with your eye and replicating them on the drawing paper with lines helps to define the surface of an object.
- The cross-contours of an object follow a path similar to that of a topographic map. Areas that are farthest from the eye should be indicated with lines that are closer together, while lines that are farther apart are used to indicate areas that appear to be closer to the viewer.
- Cross-contour can be applied in one direction or in any mix of directions as long as the mark follows the surface of the form.

Do:
- Find a simple object or use the image provided to create a lineart drawing that describes the outside edges of that object.
- Observe the inner details of the object and add cross-contour definition indicating those inner details on your drawing.

In this lesson, we will explore the importance of drawing lightly, using line-art and cross-contour definition.

Let's begin with the importance of drawing with a light touch. Learning to draw lightly is a skill worth developing for many reasons. Pencil pressure is a vital part of shading realistically, and control of the pencil affects every step of the drawing process from beginning to end. From the first rough sketch to finalizing with shade, varying the pressure of your pencil or layering tone using an even pressure can result in significant enhancements to your drawings. Subtle changes in tone can only be achieved with pencil control.

This all starts with drawing lightly. To accomplish this, the artist needs to have a gentle hold of the pencil, not a tight grip. Gripping tightly forces dark marks onto the paper while a looser hold results in lighter lines. It may help to hold the pencil farther up the barrel toward the eraser end rather than close to the tip area. Another technique to help an artist make lighter marks is to move your entire arm across the page to make a mark instead of tightly controlling a movement with a locked grip. Using small movements with your wrist and fingers limits the movement of the pencil and forces an unwanted pressure, leaving dark marks behind. Use of the whole arm enables the artist to create straight lines and smooth curves more easily. Remember, you can always make your lines darker when you decide they look good enough to make more permanent. Impermanent lines are much easier to change. Erasing a line completely can be close to impossible if the line has been made too dark to begin with. Changing a habit of drawing with a heavy hand to one with a lighter touch takes practice, but it is possible and well worth the effort.

Let's practice drawing with a light line by creating a simple drawing of two apples. This was originally a color photograph, but I converted it into black and white so the tones can be seen more efficiently. When you are drawing with tones of black and white, it is easy to become distracted when viewing an image that is in color, so transferring an image into black and white can be a helpful tool, especially when first learning how to shade. A black-and-white image can make changes in tone and shadows appear more clearly, therefore making it easier to observe and replicate the outline of what is seen.

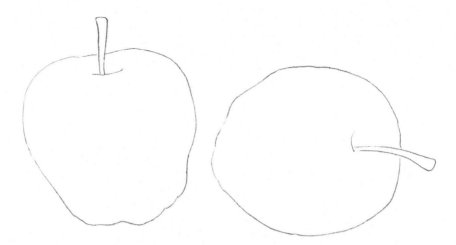

Here is an outline of the outside of the apple. This type of drawing, which defines a form or an edge, is called a contour line art. Essentially, it is the outline or silhouette of a given object or figure. Drawing the contour line of an object before drawing the inner details is one way to go about beginning a drawing. The sketching or outline portion can be drawn with an HB pencil. Once the lines are placed to the artist's liking, then they can be made a bit darker and more permanent. An artwork drawn with contour lines that consists of distinct straight or curved lines without gradations in shade or hue is often referred to as line art. Line art emphasizes form and outline over shading and texture.

Have your drawing and reference image side-by-side

Once the outline of the object is complete, the next step in this process is to focus on the cross-contour definition.

We have the outside of the object defined; now we need to describe the inside of the object using lines. Observation is crucial, so have that apple photo in front of you to determine the detail inside of each fruit. The practice of adding cross-contour definition involves tracing along the inside details of the apple with your eye and replicating them on the drawing paper with line. These lines are similar to contour lines on a map of rough terrain, which help us visualize the topography of a surface. Cross-contour lines are not usually drawn so obviously, but this practice of drawing them makes it easier to see the three-dimensional form of an object and transferring that onto a two-dimensional surface.

For instance, these apples are of the red delicious variety that have a recognizable surface showing bumps, dips, and valleys; they are more irregular than a generic round apple. To show the interior form of the apples, we will add several lines to indicate the direction and shape of those inner details. Areas of the apple that are farthest from the eye will need to be indicated with lines that are closer together according to the basic rules of perspective. Lines that are farther apart should be used to indicate areas of the apple that appear to be close-up. Keep looking at your photo to determine what the surface of the apple looks like.

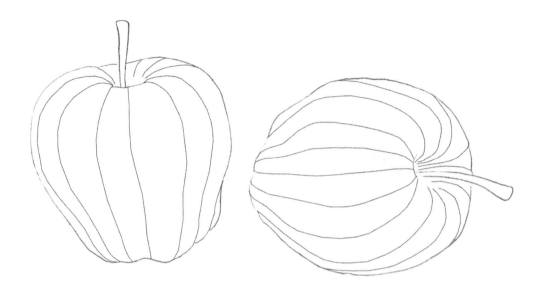

Here is what the apple cross-contour drawing could look like with line following the form in only one direction. It creates a pattern of interesting stripes that loosely indicate the form of the fruit.

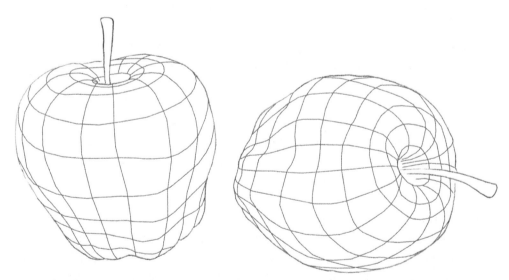

Once all of the descriptive lines have been drawn going in one direction, cross-contour-lines should be added going in the opposite direction to further define the volume of the apple. Again, notice the areas of the apple that appear to come forward and those areas that appear to recede into space. Continue to draw what you see using lines that cross over one another. By the time the cross-contours are complete, the drawing should resemble the appearance of a wire sculpture or look similar to a topographic map.

The apple on the right has been placed at a different angle than the one on the left, so the direction of the cross-contour lines will be different. Try to draw what you see, not what you think you see to demonstrate the depth or three-dimensionality of the apple. Place your cross-contour lines going in one direction and then the other to show where the surface juts out and where it appears to go inward. Keep the lines far apart for areas that are close to the viewer, and draw lines that are close together for areas that appear to be farther away. You may decide to add many more cross-contour lines to indicate the three-dimensional form or a few less; either way is correct.

This apple drawing of cross-contour lines looks interesting enough as an art work; however, we are going to take this lesson a bit further and add shade to it. These contour lines are going to be a place holder for where the shading will be placed, serving as a skeleton for the direction and depth of tone.

CHAPTER FIVE
Shading With Cross-Contour Lines

Know:
- Shading using contour lines as a guide.
- The source of light will determine where shadows and highlights on an object will be placed.
- Reflected light is the light that reflects onto your object from areas around
- your object. Reflective light is always located on an object's shadow side.

Understand:
- Being aware of the flow of cross-contour lines as you draw can help to create a shaded surface that follows and enhances the three-dimensional form of an object.
- Creating layers of shade helps to define the form of an object quickly.
- Following the curves of the contour lines when adding value makes a drawing appear more realistic.
- Observing your photo or reference image frequently can help to ensure that the main shadows and reflections are in the right places.

Do:
- Using cross-contours as a guide for shading can help to show depth in an
- artwork.
- Observe your reference image to determine the dark and light areas.

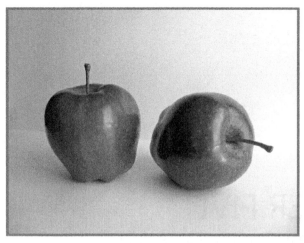 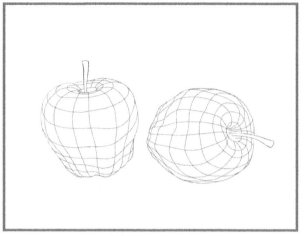

To begin shading, make sure you still have the apple photo in front of you for reference. Decide which area you plan to fill in first. I like to shade in the darkest areas first because it helps me to block out the whiteness of the paper and adds a quick indicator of depth. Creating contrast against the blank paper right away can be easier on the eyes and helps to define the form of an object more quickly. The darkest areas seen on the photo fall near the left-hand side of each apple, mainly because the light source is coming from the right. In order to replicate these shades and shadows, follow the direction of the cross-contour lines and fill in those dark areas using a back-and-forth motion with the pencil.

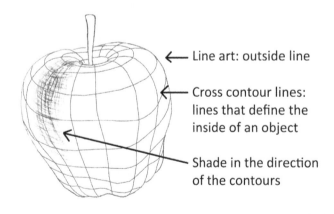

← Line art: outside line

← Cross contour lines: lines that define the inside of an object

← Shade in the direction of the contours

It is a good practice to not fill in the shadows to their full intensity of darkness right away. Create a preliminary layer of shade first and barely fill in areas that need shading by using a light touch. We will continue to edit the shading, as the drawing progresses and a lighter touch makes it easier to erase or move shadows and light spots if needed. Lay down some to lines indicate where the shadows are going to be that follow the peaks and valleys of the apple in a curved motion. A back-and-forth straight motion could be used; however, shading in the direction that the apple curves into helps your artwork to look much more realistic; therefore, follow along the cross-contours when adding value. You will need to go over some areas a few times in order to get the depth realistic. Laying

down that first initial layer of shadow is helpful as it becomes easier to look at when the vast white of the page is taken away. Notice where the apple divots in according to the contours and where it bumps outward. The areas that appear to curve inward will be a little bit darker while areas that stick out will be a little bit lighter. Continue to follow the curves and lightly fill in the apple with shades that you see. Remember this is just the first, initial lay down of tone.

Moving toward the right side of the apple, the tone will become a little lighter. You can let up on the pressure of the pencil or switch to a lighter B grade pencil. In the light area, notice that there is a highlight on the photo that should be captured in the drawing. The highlight is almost white. Leave the very brightest parts of the drawing white or go back later and use the eraser to remove the pencil and make a highlight or reflection. As the apple starts to take shape, go back and add more layers of shading. Gradually lay a thin layer of shade over the apple once more, darkening where needed. The contrast between light areas and dark areas should become more clear and distinct. Now is the time to change the direction of the shading motions to follow the opposite cross-contour. Following those cross-contours with shade is going to add more depth and detail.

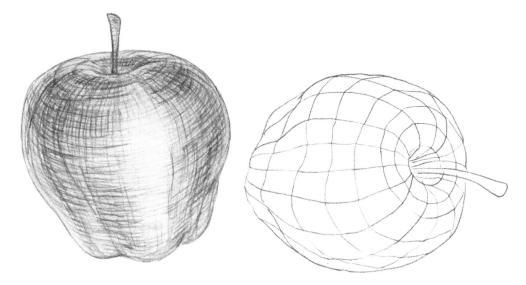

Observation is crucial, so stop drawing every once in a while and step back to view your work. Refer to the photo or reference image frequently to compare it with your drawing to ensure that the main shadows and reflections are in the right places. Take a look at your apple, then take a look at the photo to see if the tones are matching up. It can help to squint at your work when doing this because squinting simplifies tones and makes them easier to see. If you're hovering over your work constantly, it can be difficult to get

a good idea of what it looks like from a distance, the way the artwork is supposed to be viewed. Also, when laying down tones, use your value scale as a guide. This will help you remain consistent throughout your drawing.

We already know that the light source is coming from the right side of the apple, which is showing that side of the apple to appear lighter. That light source also lightens a sliver of the surface in the shadowed area. This tiny area on the far left is called reflected light. Reflected light is a faint light that is reflected or bounced back on an object from the surfaces close to and around it, modifying the tone of the object. Reflected light is especially noticeable on a rounder object such as a sphere or the apple.

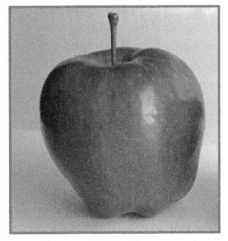 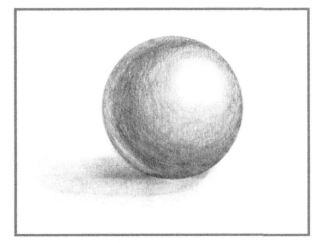

Notice the rim of reflected light on the left side of the apple in the photo as well as on the illustration of a sphere. Leave a rim of light shading on your drawing in the darker shadow area to indicate the reflected light bouncing back from the white surface on which the apple is sitting. Keep following the cross-contours, adding and removing tones as needed. Keep looking at your photo compared to your drawing. That is where all the answers are. Also, remember to draw what you see, not what you think should be there. You know in your mind what an apple looks like, and sometimes your mind tries to fill in the blank areas or areas you are unsure of with something untrue, making things up if they are not clearly visible. This is where an artist can get into trouble and change the whole dynamic of the artwork. When you try to make things up, the art may not come out quite right, especially when you're first learning shade from real life. Drawing from imagination, creating abstract and fantasy works, or things that are not from real life are a different story; however, an understanding of shading realistically will help imaginary works become more believable. For the best results when shading realistically, draw what you see, not what you think you see.

Also, do not to add a dark outline around your drawing to define the edges. As the shading becomes deeper, the original outline of the drawing should begin to blend in with the shadows. In real life, most things don't have dark outlines around them but rather a change in value. The same should be considered in a drawing; the outline should not get darker, only the shadows.

Once the tones on the artwork represent those in the photo, finalize the details. This may involve blending the tones or removing some tone with the kneaded eraser. If the highlight in the photo is a lot lighter than the one in the drawing, remove any pigment necessary to get a better likeness. The goal is get a believable contrast between dark and light. Start with the obvious highlights on the right-hand side, then seek out the not-so-obvious highlights. Make sure to include the reflected light on the left. Continue to tweak the shading until you are happy with the results.

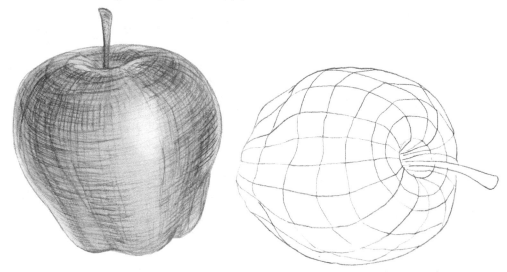

Cross-contour lines are often used when shading with hatching and cross-hatching. For a realistic look, these lines may be drawn all the way around the form or drawn in short, curved lines.

The direction of the lines should move around the form being shaded and should change according to perspective.

An artist should be aware of the flow of cross-contours as they draw to enhance the three-dimensional form.

The lines and shadow created for this particular exercise do not need to be blended for a smoother look. The goal is to draw the lines following the direction of the contours in such a way that they flow into one another and do not need to be blended. Once this technique has been practiced, it can be applied to your art and blended as desired.

Student Work, Questions and Comments

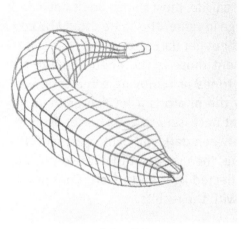

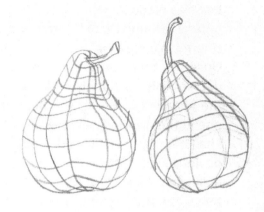

Artwork by TCH Artwork by Whitney Freeling

Question: I had a really hard time with this lesson. The number of pencil strokes I see is overwhelming. I'm trying to go with your tip of only using my blending tool minimally so I won't lose the texture I have created. I am trying to do lots of layers of shading, but I am still unsure of my technique. Do you have any advice on this?

Reply: There will be many lines once your artwork is complete, but if you draw just one line at a time while observing the direction of the surface of your object, it should be easier. Looking at an object in small parts as opposed to a whole should make tackling a drawing simpler. To address your use of blending, this cross-contour line lesson is not about smudging or blending tones together; it's about seeing all those beautiful lines that describe the surface of the object and laying a skeleton down to indicate the outer and inner forms. Think of your artwork as a topographical map of your object. Lines on a typographical map flow over the form of the object and are closer together in locations where the elevation changes. We can understand the form on an object by following the "lines" within its shape. Drawing with cross-contours is more of an exercise than a final, refined product.

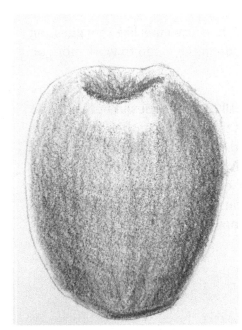

Comment: The apple is okay, but I feel like I need more practice.

Reply: Keep at it; it's looking good. Remember, this is just an exercise in creating tone on top of cross-contours. You have added a good amount of depth to the apple so it appears three-dimensional.

Artwork by Tamara Eden

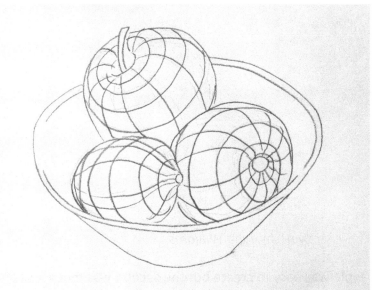

Artwork by Zoe Nickerson

Question: I don't like seeing all of those lines in my finished drawing. When you use this technique, would you normally try to draw the contour lines very lightly, or is this more of a study technique?

Reply: Go ahead and draw them dark enough so they can be easily seen once you are happy with the placement. This is definitely more of a study technique, the idea being that once you have practiced this method enough, you no longer need to place the cross-contours and can see them as you are shading.

Comment: This exercise was not easy for me because I feel like I am guessing where to put the shadows and highlights. I definitely need to work more on that to make everything look more realistic.

Reply: Areas of shadow and highlight and all of the shades in between can become difficult to see because sometimes the changes in their tone can be very subtle. If you are not using a black-and-white image as a reference, try that first. A black-and-white image can make changes in tone and shadows appear more clearly, therefore, making it easier to observe and replicate the outline of what is seen. Another option to try when locating shadows is squinting your eyes. This simplifies a complex image into areas of chunky shadows that are easier to pinpoint.

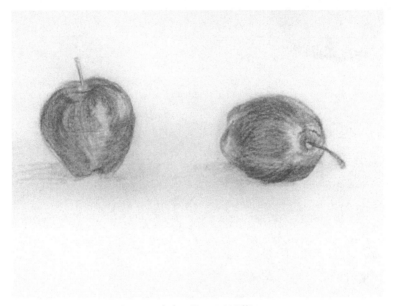

Artwork by Tyna Williams

Question: My first apple was easy to create but the second was much more difficult, especially drawing the stem area. Any suggestions?

Reply: The second apple is angled differently than the first so I'm not surprised that it was a bit more challenging. If you're looking at the photo that I provided, I'm thinking that the area near the stem could be a bit more round or full. The darkest area near the left should be even darker, and the contours should be more pronounced. The highlights are placed correctly, and the reflected light (which is sometimes hard to see) has been duplicated well. As for the direction of the stem, find a straight edge (a ruler, piece of paper, or your pencil) and align it with the stem in the reference image. Notice the direction your straight edge follows. Now compare the direction

of the stem in the image to the one in your drawing to see if they match and adjust where necessary. Looking at these features as compared to the edge of your canvas/paper can also help to determine if you have captured the direction correctly.

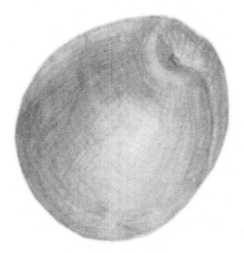

Artwork by Naila Dautova

Comment: I used an HB #2 pencil and had some difficulty with dark spots and making transitions from dark to light.

Reply: Using a 2HB pencil takes a little bit more work than when using a variety of drawing pencils. You have to vary the pressure more with a 2HB, and the range of tones are not as vast. That being stated, you can still get a decent shaded artwork when using this type of pencil. It will be more time consuming and more varying pressures involved.

Comment: I tried this a couple of times but still felt like I was missing something. I focused on the different gradations of tone, but the contrast wasn't prominent.

Reply: Try and take your darkest tones a level or two deeper while taking the lightest tones and removing them completely so they become highlights. This will offer more contrast and interest, perhaps adding the component you think may be lacking.

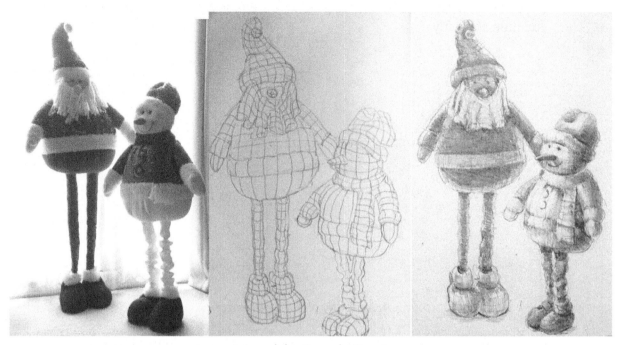

Artwork by Pamela Dowie

Comment: Should the cross-contour line go from edge to edge and from bottom to top for each line? I noticed when I was drawing my objects, I began to vary the width to show the contours. I erased some of the lines, as they seemed to disappear into smaller/tighter areas but then thought maybe it was unnecessary to erase.

Reply: The cross-contour lines do not have to go from edge to edge or top to bottom for every line. Sometimes the shapes, valleys, divots, etc. you are representing with cross-contours will appear to fall behind other shapes, dips, valleys, etc. This is how we show perspective. Varying the width of spaces between your cross-contour lines is exactly what you should do when representing the information inside of your object. Lines should be made far apart from one another to represent areas that are close to you while lines closer together are placed to represent areas that are farther way.

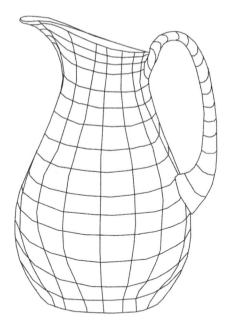

Artwork by Owen Andrews

Question: I find this method helpful, but I am still having trouble drawing the areas where the lines should be close together. How can I fit them in?

Reply: Try and draw on a larger scale. There are so many more opportunities to add details and intricate shading when you allow yourself more space. If you want your final drawing to be a smaller scale, a good trick to try is drawing large and then shrinking the artwork on the photo setting of a photocopier. You will be amazed at the fine details you will see! This works best with black-and-white drawings.

Question: What shapes should I make with my pencil?

Reply: Just follow the contours of the apple, holding your pencil at a slight angle in the process.

Question: Do the lines have to be even?

Reply: Cross-contour lines do not have to be even or go all the way across an object. These lines are used to help an artist describe the three-dimensional form on a two-dimensional surface. Contours wrap around a form and obey linear perspective; they do not have to be obvious and can suddenly end to indicate a change in form. The viewer's imagination will fill in the rest since surprisingly little information is needed to be drawn in order to understand three-dimensional detail on a simple drawing.

Comments:

"I absolutely believe the cross-contour technique has helped me to create more realistic shading. I have never really been able to achieve believable shading before. This lesson has worked wonders for me, as the cross-contour technique was a real breakthrough. I plan to set up some objects from around my house and try the technique as much as I can because I found it incredibly helpful. I think the more I practice, the more things will start sinking in for me. I am not a 'natural' artist, but I really have a desire to draw and paint."

"I like the organized way this cross-contour lesson guides me through the process of seeing inside details of an object. Plus, it gives me a better eye on a piece."

"I struggled with exactly where to draw the contour lines. I guess that comes with practice. It was a revelation to learn the cross-contour method."

"This was a very valuable lesson. I like the way the contours are a map for direction of shading and light."

"I found this lesson really helpful. I am more aware of form and the direction of my shading by observing the contours. If I find that I am having difficulty placing shade and shadow, I will sketch in some cross-contour lines."

CHAPTER SIX
LIGHT SOURCE AND SHADOW

Know:
• Recognizing a light source within a scene
• Shadows, highlights, and blending

Understand:
• The direction of a light source will affect the placement of shade and cast shadows on an object.

• Shading will help to define the edges of an object (without outlining) and give the appearance of a three-dimensional form.

Do:
• Use learned techniques to take a simple organic shape (blob/cloud) and turn it into a realistically shaded object that shows depth and dimension.

In this lesson, we will focus on light source and shadows. This includes identifying the direction of a light source and seeing how that light affects the shadows and cast shadows on an object.

Once an artist draws their object or composition, they should decide which areas should be light and which areas should be in shadow. When I begin to draw, I like to start with the darker areas first and then gradually work around the entire drawing to fill in the remainder of shade. Another approach that some artists use is to lightly fill in the entire object with a single shade before adding detailed contrast. The latter method can be helpful, as it blocks out large areas of white, helping the item to take form quickly and

offering a view of completeness to the artwork, regardless of whether it is finished or not. Whichever technique is used, the addition of shading will make any object appear more realistic while adding interest and depth.

One way to demonstrate this can be illustrated through the creation of a simple drawing of an organic blob.

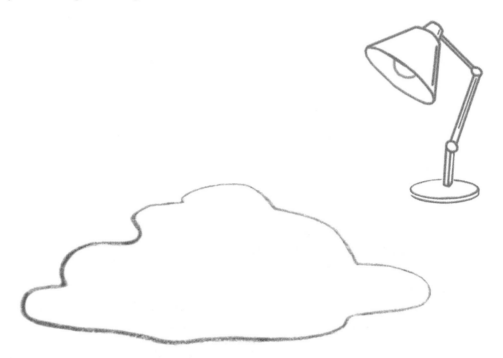

Start with a very light and sketchy organic cloud-like shape. Our goal is to add shading to this shape so that it appears to have depth. Shade will help to define the edges and give the appearance of a three-dimensional form. For the purpose of this example, I have chosen the light source to come from the top right area, leaving the bottom of the shape and area on the left in shadow. You do not need to draw a lamp or light source on your drawing. I drew a lamp to indicate my light source so you, the viewer, can easily determine where the light should be coming from. As stated previously, I like to shade in the darkest areas first. This gives me a point of reference to start at, and it also helps me to block in certain shapes that may be formed by the inner details (cross-contours) of an object. I will also add some darkness inside the shape to indicate ripples or folds to try and make it look a little bit more blob-like.

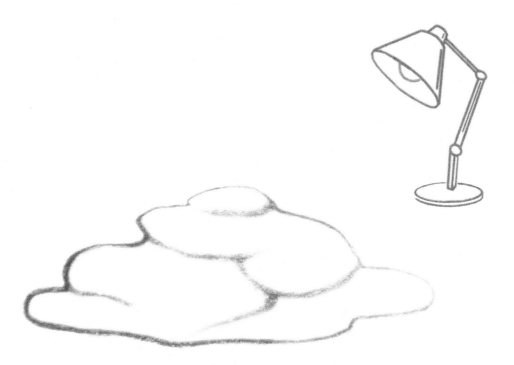

The above illustration shows a few curves inside the shape that represent folds or layers within the blob. These lines will help to describe what is going on inside the shape, forming a type of cross-contour to define the depth.

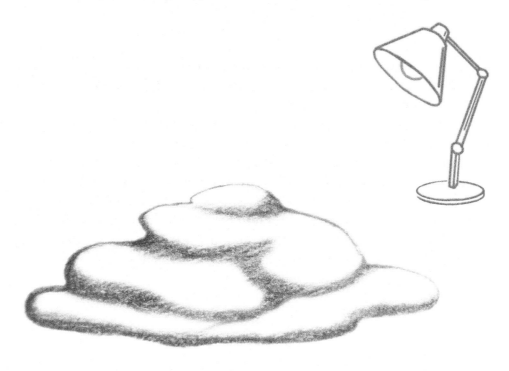

Next, I have added some more shadow to the folded curves by using the edge of a pencil to place tone and widen the lines. This will blur the sharp edges created by the original lines. The width of the shaded lines should be thicker in the areas farther from the light source. These marks should also be a bit darker in the areas farther from the light.

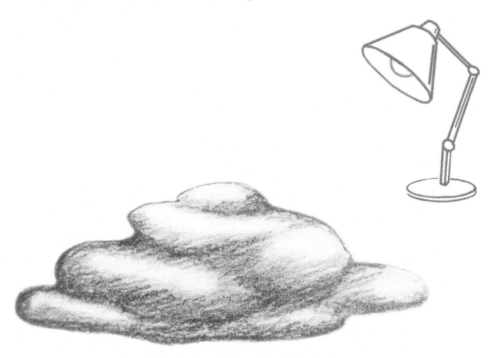

Once the darker folds have been identified, the remainder of the shape can be filled in with a light back-and-forth motion of shade to diffuse some of the bright white of the paper, leaving only the tops of the folds untouched. Creating slight contrast between the image and the background can help the image to stand out from the white of the paper and can also give the artwork the appearance of a certain level of completeness. Once a light layer of tone has been placed over the whole blob, the tones can be blended in to appear smoother. With a paper stump or a finger, gently rub the pencil marks in a back-and-forth motion to get the tones to appear smoother and slightly blend in to one another. Rub just a few times in order to slightly blend the tones but not too much blending so that the difference in tones is not noticeable anymore.

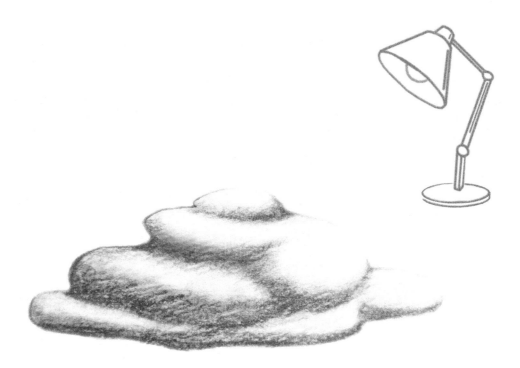

Once you have all of the white areas blocked out, go back and define the shadows more with a darker tone. Add another layer of darkness as needed to intensify the shadows on the underside of the blob. As it starts to take shape, add more ripples or folds as desired. The 8B pencil is a good choice for creating these darker shadows. You might want to hold the pencil closer toward the point when pressing hard, which will help to make a darker mark. For lighter marks, it helps to hold the pencil farther away from the pointed end, which prevents the artist from pressing too hard. To create more of a contrast, highlight the areas that are closest to the light source coming from above. Highlights can be intensified using the kneaded eraser to remove pigment on the tops of the curves and areas closest to the light source. The eraser can be reshaped as needed to form curves and highlights. Using a dabbing motion or back-and-forth motion, remove some of the pigment so the blob has a few areas of highlights near the top. The addition of light highlights to the darker shadows adds the appearance of volume, definition, and depth. Erasing parts of the original outlines so they are barely visible on the areas nearest the light can help with the realism of the shading as well.

Using these techniques takes what was once a shapeless, uninteresting blob and turns it into a more dynamic, interesting object.

The addition of shading can make any image look more realistic and interesting.

Here is a fun exercise to try using a cartoon. Find or draw a simple outlined image of a character. Choose a direction in which a light source will be and shade in the item accordingly. Take each section of the character and shade in the darks and lights, one area at a time, until the whole figure has value. This is a quick way to practice adding value to a simple object to make it look more realistic. Although the cartoon will probably not look real, the addition of shadow will add interest and depth.

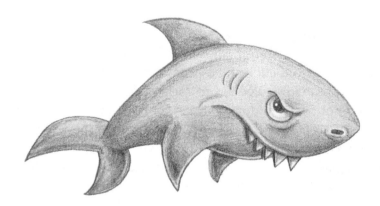

Student Work, Questions and Comments

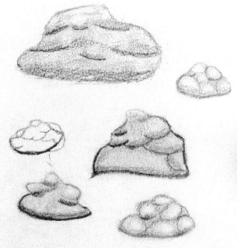

Question: I had so much fun drawing these blobs! I particularly enjoyed watching a simple shape come to life and appear three-dimensional. I find it easier to shade when I get to pick the direction of my light source. I instinctively know where the object is supposed to be light and dark. When I look at objects in real life, I find it harder to determine where to put the darks and the lights. Why is that?

Reply: These are great blobs. When you are drawing from imagination, there is no observation involved; therefore, it is easier to manipulate what you want your object to look like. It can be difficult to observe reality and replicate it. This exercise is great for placing simple shadow and highlights. These tones, along with the subtler midtones can be harder to see on a real object.

Question: I am in no way an artist, but I am intrigued by shadow and light. As I worked on the blob, shadowing and eliminating pencil, I suddenly saw this creature emerge. It delighted me so much, that I continued. Am I getting the idea?

Reply: You are getting something even more than the main idea behind this lesson. The blob sketch is basically a way to practice making the 2D appear 3D. You are now looking beyond that and finding a likeness within the form you made. How wonderfully creative to get inspired when you least expect it! You are now seeing the same image that everyone else is seeing but with a fresher perspective, or new set of eyes. You are seeking alternative ways of looking at a problem and opening other ways of thought. You are on the pathway of seeing like an artist does.

CHAPTER SEVEN
SHADING A TREE REALISTICALLY

Know:
• Shade, highlight, cast shadow,

Understand:
• When light illuminates an object, the part of the object that remains in the darkness is called the shade, the lightest area is called a highlight.
• Using a reference image when drawing can help to elevate the naturalness/realism of the artwork.

Do:
• Draw a simple tree that has a specific light source, and shade it in using the techniques provided to indicate highlights, shadows, and cast shadows.

Light and shadow helps to visually define an object without using dark outlines. When light illuminates the object, the part of the object that remains in the darkness is called the shade. The shadow that is created by that object is called the cast shadow. By pinpointing the location of the shade and cast shadows, you can usually identify the light source. When there is only one light source, all shadows are cast in the same direction. If this object is to be drawn on paper, the cast shadow and shade will appear to be the darkest.

Highlight

The direction from which a dominant light source originates is going to be the lightest area on an image. The lightest area is called a highlight. Where this light area appears on a particular surface depends on the location of the light source and the angle of the surface. The placement of a light source on an object affects every aspect of a drawing, including the placement of shadows (which also indicate where the light source is).

By locating the darkest and lightest values on the object, an artist is one step closer to creating a more realistic representation with shading.

This next exercise will demonstrate a drawing of a simple tree that has a specific light source to indicate highlight and shadow.

Here is a sketch of a simple tree. Young children and amateur artists are likely to draw trees such as this, representing them without much detail using a rectangular or slightly curved trunk with an organic tuft at the top to indicate leaves. This approach may seem basic, but it is a decent representation of an uncomplicated tree. The viewer is able to recognize the image immediately because it is based in reality. A more advanced drawing of a tree can start off similarly to that of the child's drawing with simple geometric and organic shapes; the artist will simply add detail and value to the image.

There are over 100,000 species of trees in the world, which means one tree might look vastly distinct from another. In fact, even trees within the same species can look different from one another.

For the purpose of this example, we'll illustrate a generic, all-purpose tree. Even though the tree is non-distinct, the steps in this tutorial are fairly universal and can be useful whether you are drawing a pine, maple, ash, or any other type of tree.

If you plan to draw from life, find a reference. Drawing from imagination can be a wonderful experience, but sometimes we need some guidance when constructing a realistic artwork. Using a reference image will help to elevate the naturalness of a drawing. To find what you are looking for, research pictures online, go out into the world and take photos, or just observe the things around you. With the vast array of images available, there is no reason not to get as much information as you can from the resources accessible to you. Experiencing images in the world around us can help us to develop a better perspective. Looking at and studying your subject matter will help you capture a likeness, help your ideas to become clearer, and help you to visualize the fine details (How to Draw Cool Stuff, 2016). References should be used even when drawing from imagination, even though fabricated creatures or scenes are not just simply re-creating reality. Using information based in reality (such as studying the shade, form, and structure of existing objects) is essential to creating believable fantasy images.

When I draw a tree, I like to start off by making the trunk a bit leaner than the standard, simplified rectangle. Below is a tall, lean trunk with minimal branches. Most of the branches will eventually be covered with leaves so it is not necessary to draw all of the branches. Consider these lines to be an underlying skeleton to add detail to. Notice the angle of the branches is slightly upward. Branches usually grow up and outward toward the life-giving sun. Do not use a ruler for this process, as a natural tree will show lumps, subtle curves, and asymmetry. For more organic results, stay away from perfectly straight lines.

Create an outline for the structure of the tree. Using the basic trunk sketch, add light curved lines surrounding the trunk and branches to serve as a guideline for the leaves. Make these curves into an organic cloud-like shape that is slightly wider near the trunk middle and narrower near the top. The shape of this will likely change once we start adding detail, but initially blocking in the general area helps an artist to visualize the final product. Don't make it perfectly symmetrical–trees are organic structures and are never exactly the same on both sides. Create a basic shape that looks good to you, using your knowledge of trees or from a reference image.

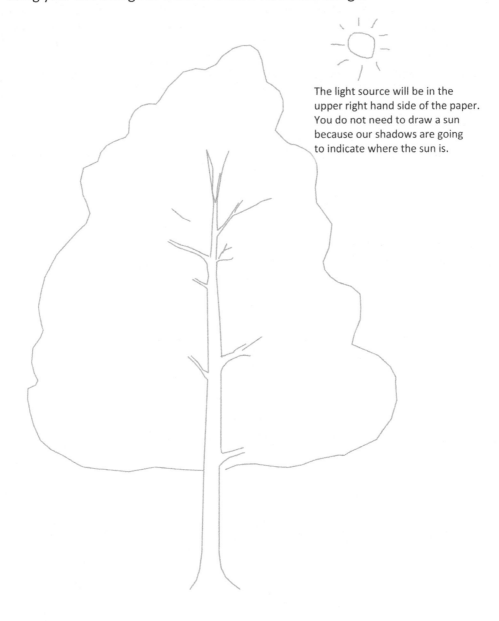

The light source will be in the upper right hand side of the paper. You do not need to draw a sun because our shadows are going to indicate where the sun is.

Shade

Once you have placed your trunk and leaf areas, the shading process can begin. When some people start to shade, they often think that an object needs to be completely light on one side and completely dark on another. This is not necessarily so, especially when shading a complex, layered object like a tree. The surface of a tree is inconsistent, including little tufts of leaves that jut outward and areas of void that move inward. All of these changes on a surface need to be indicated with shadow. This might mean that some areas of the tree that are on the shadow side might appear lighter and some areas on the lighter side may appear dark. Before you begin to add the shade, determine the main light source so you know which areas of your tree will be highlighted and which areas will be in shadow. This will also determine where the cast shadows will lie. For this example, the light source will be coming from the upper right. There is no need to draw a sun because the shadows and shading will indicate where the sun is located. Areas near the light source will be the lightest values, areas farther away from the light source will be the darker values. This rule is subject to change as the drawing progresses since there are many leaves and a variety of layers to the image that will jut outward or recede inward.

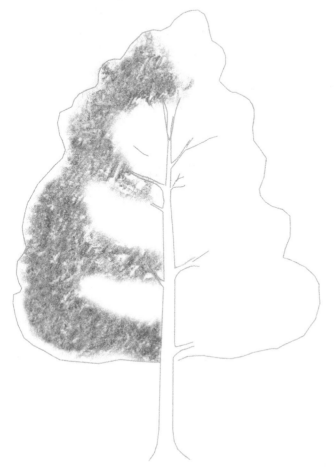

Begin blocking in areas that will be the darker with a light circular, scribbling motion. These dark areas will be on the left side of the tree. Just like the blob we drew in the previous lesson, there should be some lines or darkness within the outlined structure to indicate layers, ripples, or folds. The majority of these folds will appear in the darker left side of the tree; however, some will creep into the portion on the right, even though the light source is on that side. The darkest values and deepest textures will appear on the underside of the leaf canopy. Lighter values and texture should be applied to the tops of the canopy and folds.

For a medium tone, I used a 6B pencil in short, circular curves to resemble a leafy texture. The scribbling keeps the leaves loose and not too detailed. Continue to fill in the tree using clusters of circular scribbles. The bottom of each tuft of leaves should be slightly darker than the top. Tip: Hold the pencil at an angle as opposed to perpendicular to the paper. This will help to cover and block out a large area at a time. If the pencil is held straight up and down, it will take longer to fill in areas of white and the line made by the pencil will appear finer. Scribbling can be a little tricky, but when done correctly, it adds texture and fills in the initial areas of shade quickly. Using that motion, concentrate on making the tree darker on the right-hand side and on the bottom. The textural marks that are made should stay near the confines of the lines that define the canopy; however, they may slightly overlap. Remember to focus on drawing a texture that appears as a concentration of leaves as opposed to individual leaves themselves.

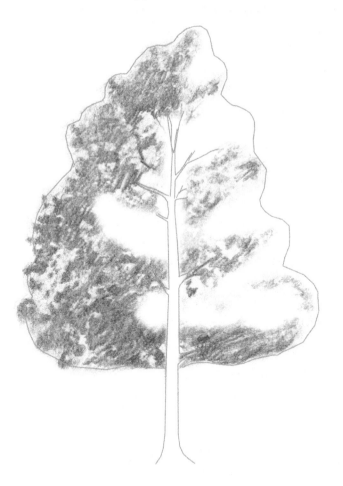

Bring some more areas of the shade in from the left toward the right to indicate the layers of the leaf tufts. If you make an area too dark, go in with the kneaded eraser and dab at the darkness to pull up some of the pigment. Some tiny areas in the darkest shadows can be lightened with the eraser for added depth. It may take a few layers of texture or passes with the eraser to develop the balance necessary to create the illusion of leaves, but it will be worth the time.

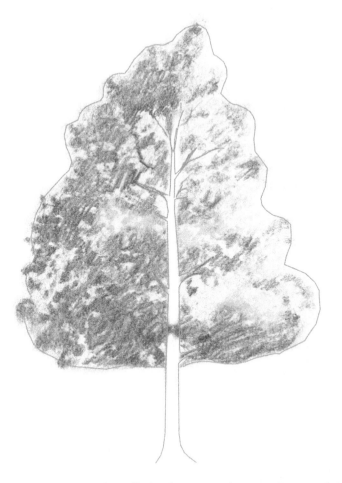

In order to fill in the leaf area quickly and remove some of the white to create contrast with the background, a light layer of tone can be added to the remainder of the leaf area. This helps to make the image appear more complete. Areas of only the lightest highlight can be erased to a stark white with the kneaded eraser.

Not only will the leaves indicate where a light source is but the shadow on the trunk is also going to reiterate that the light source is coming from the right. Since the light source is on the right, the left side of the trunk and parts of the exposed branches will be in shade. When shading the trunk, start shading the darkest area first and then gradually move to the right while letting up on the pencil pressure to create a lighter tone. This can be done with a quick back-and-forth motion. There should be a thin sliver of lightness on the left at the edge of the shadow area to indicate reflected light or light that has wrapped around the cylinder of the trunk shape. We want the tree to appear tubular and not flat so the light source that's coming from the right-hand side will wrap around and offer this bit of lightness within the shadow.

Add a simple root system at the base of the trunk so the tree doesn't appear to end unnaturally or float in space.

A little of the tree trunk and some branches can show through the leaf area in a few small spots here and there.

This may take a little bit of tweaking and some time to fill in until you are happy with it. Keep working on it, remembering where the light source is and where the dark areas are. As you continue to shade, the original outline of your drawing should begin to blend in with the tree. Just as objects in real life are not outlined, your realistic drawing should not be outlined either. Use the kneaded eraser as needed in order to create sharp highlights and a natural blending of tones. There should not be a crisp line of demarcation from one tone to another but rather a smooth transition from one tone to the next.

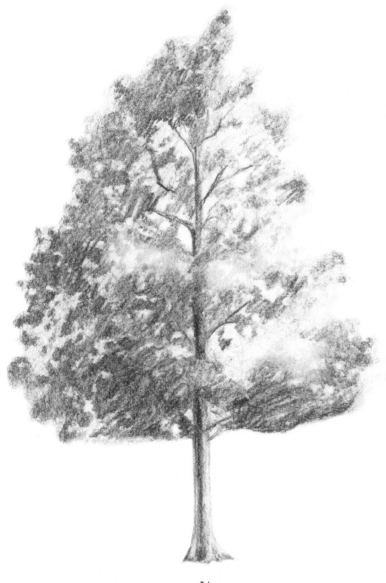

Cast Shadow

Finally, we will add a cast shadow on the ground, which will reinforce where the light source is coming from. Consider a cast shadow to be a more simplified version of the object that is producing it. In this case, we will create a medium-toned area coming from the tree base, headed in the direction away from the light source. The cast shadow can indicate not only which side of the tree should be light and which side should be dark but it can also indicate the time of day (and the sun's position in the sky) depending on the angle of the shadow.

Shadows do not have much detail but can retain the general shape of the object that is casting that shadow. A simplified trunk with a few scribbles to represent the leaves will suffice in this case. The shadow should be its darkest where it meets the trunk at the base. Once the shadow has been placed, the tones can be blended with a finger or paper stump for a velvety finish. If the highlights are blended in too much, use the eraser to redefine them.

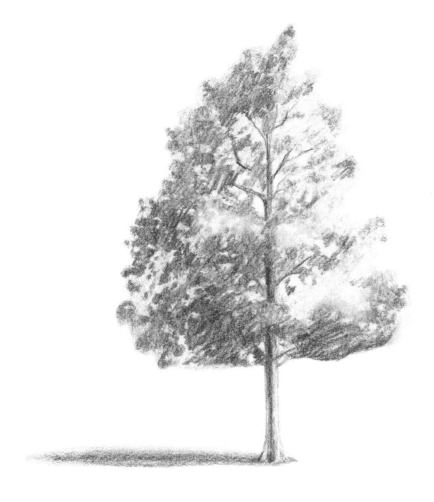

Creating the illusion of a realistic light source affecting an actual object takes practice and observation.

The best way to understand the concept of light source and shadow is to place an object on a table next to a window or single lamp. Observe it from different perspectives and practice shading it, focusing on the light source and how that light affects the actual object and surrounding areas. Simple objects work best when first starting out.

Practice by drawing an organic blob, apple, or other simple object and shade it so that it indicates a clear source of light. Next, try to draw a tree from a photo, life, or your imagination and shade it using the techniques provided. Decide where the light source will be and add a cast shadow to the tree in order to solidify the direction of that light source.

Tips for drawing trees:

• Avoiding drawing the tree trunk straight into the ground since most trees have a slight indication of roots and curve outward near the base.

• Remember that trees have the shape of long tubes, and the shading should appear to represent a cylindrical object. This can be done by using curved lines when shading as well as gradients in tone.

• Change the pressure of the pencil stroke to develop depth within the object. The darker areas should have a heavier weighted line or deeper pressure while lighter areas should have a lighter weighted line or lighter pressure.

• A common mistake is drawing the branches and trunk with straight lines. Adding small bumps, knots, and bends helps to make a tree look realistic.

• Observation is key. To figure out what tone to make a section of a drawing, just observe the subject and compare. This becomes easier with practice.

• Perspective. The detail added to the tree depends on the perspective of the viewer and the distance the tree will appear to be away from the viewer. A tree that is far in the distance can have small scribbles and simplified details. A tree that is a close-up or has a detailed view will need finer detail.

• Always know where the light source is coming from. This will impact every step of the shading process. If you are unsure, one trick is to locate an object's cast shadow. Once you have determined this, you can easily discover the direction from which the light source originates.

• The open spaces within the tree are crucial. Be sure to add a few of them for a realistic artwork.

• Use a range of tones when shading, making the darkest areas in the shaded area and the lightest on the highlighted area.

Examples, Questions, and Comments

Question: I tried to draw a tree several times, and I am going to do some more because I don't think I put enough shape into the fluffy parts. What should I do to add more shape? What technique is the best to use when adding leaves?

Reply: There are a lot of separate shapes that make up the leaves of this tree. Step back from time to time to make sure the tree leaves appear as one unit, not separate parts. It looks a bit too perfect and uniform. I find that the circular scribble motion works best for me, but everybody is different! It's good that you're trying different techniques. The one thing these all seem to be is symmetrical in shape and rather full. Try making more of these same types of tufts of leaves but with more jagged edges and smaller clusters that blend into one another. You can add a ridge of deeper tone to separate them without outlining them completely. Sometimes, just a sliver of shadow in one area can be very descriptive.

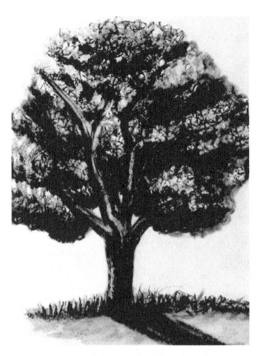

Question: Can you please give me advice on the shading and light source of this tree. It was drawn using charcoal pencils.

Reply: This is beautiful! If I had one piece of advice to give it would be make the some of the dark areas a little bit lighter. Charcoal is a tough medium to go lighter with once you have laid down dark pigment. To create contrast and interest, a balance of light and dark is needed. A smoother transition from one to the other along with the addition of some midtones may help it to appear more realistic.

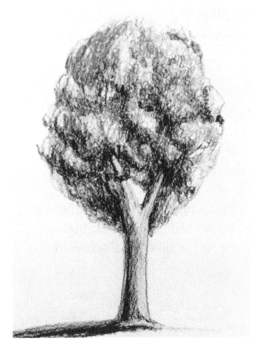

Question: Here is my tree. I realized at the end that I hadn't left enough room for a proper cast shadow, so the shadow is quite wonky! How can I fix it?

Reply: That can happen sometimes. I sometimes make parts of an image too big, but I try to use any "mistakes" to my advantage. This might mean that I and crop my artwork in an interesting way or adjust my light source. Your shadow works, it just puts the sun in a different position in the sky than perhaps you originally intended.

Question: Sometimes I feel like my light source and the actual shadow don't line up where they should. I get confused on where to make the shadow because if I draw the shadow where I see it, it doesn't match the direction of the light source. Why is this happening?

Reply: Sometimes when an artist is drawing a scene, they will find that the shadow placement varies because there is more than one light source, especially if there is artificial light being used. This causes shadows and shade to be unclear or inconsistent. Since there is not one light source, there will likely not be a sharp shadow that is the easiest and most intuitive to draw. Multiple points of light cause scattered shadows. If there is no direct light source seen and everything is in shadow, that's the result of diffuse light. Usually, any one cast shadow will be darker where a second shadow falls upon it. Any number of shadows can be cast from an object, the darkest part of the shadow is the area where the greatest number of cast shadows overlap. This is usually closest to the object itself. Being aware of this will help when trying to tackle these shadows. It is always better to draw what you see, not what you think you see, in order to get the most realistic image.

Question: For me the most difficult part of shading is figuring out where to put all the shading and how far out to bring that shading from the object. How far out should I put my cast shadows?

Reply: Shadows look different, and even take on different shapes, when cast from different perspectives. The placement and size of cast shadows can be somewhat tricky. Always look at the shadow in relationship to the object that is casting it and decide whether it is smaller or larger than the object. That's always a good place to start when considering size. A light source that is far away from an object will cast a shadow similar in size to that object. A light source that is close to an object will produce a larger shadow. This can be seen easily when using artificial light.

Question: I find it difficult to make things look curved. What can I do to help create shading that looks more round?

Reply: Make marks with your pencil that follow the contours and cross-contours within an object. This means that instead of drawing with straight up-and-down or side-to-side marks, shading should be made with curved marks.

Question: Do you have any suggestions for shadow angles? Mine all end up curved.

Reply: Do you mean shadows from a cast shadow? Try to hold your pencil with a looser grip. Sometimes if you can handle it closer to the eraser and farther from the tip end, it forces you to have a lighter hand. I would suggest lighter pressure and. curved motions with the pencil. If you find that you are still making sharp angles, remove some of the pigment with your kneaded eraser and blend.

Question: Do you have any suggestions on how to separate the leaf clumps from each other and the trunk?

Reply: Use shadow to do this, definitely not outlines. You can add a bit more shadow at the bases of each leaf tuft. Also, some white space can be left in a few patches randomly near the trunk.

Question: I tend to try to copy exactly what other people draw then compare it to mine. Do you have any advice for me so I can stop doing that?

Reply: Yes, stop doing that! It's nice to have a frame of reference or image to use as inspiration, but it is better to look at an actual object for that as opposed to someone else's artwork. If you have to compare your artwork to another, compare it to your own artwork from the previous creation. You might find that you are pleasantly surprised!

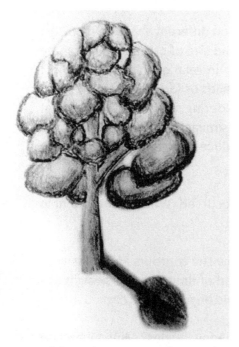

Artwork by Whitney Krug (age 12)

Question: I drew this tree from my imagination, not a picture. What does it need?

Reply: Using your imagination is a great way to be creative! When you're trying to draw realistically, it helps to start by drawing from life or from an image. Having a reference photo to look at to see where the shadows fall and where the light hits is an important part of the learning process. Is it possible for you to go outside and observe a tree or perhaps look online at a few trees with leaves? If you can, notice the organic shape of the trees' outer contours. Notice the areas where the leaves go in toward the tree more and how they are not necessarily very smooth. It is important that you observe an object similar to what you are trying to create.

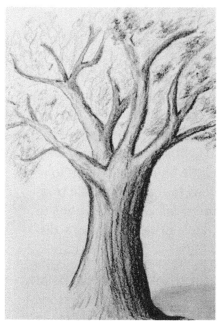

Question: How can I improve my tree?

Reply: The shading appears to be in all the right places. Perhaps your lines could be a little bit finer, and more branches would make it appear complete. As it stands, this has a beautiful, loose illustrative quality to it.

Artwork by Tamara Eden

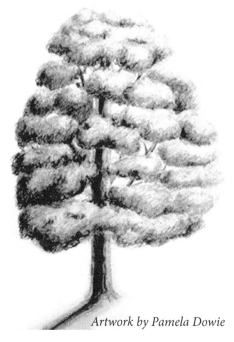

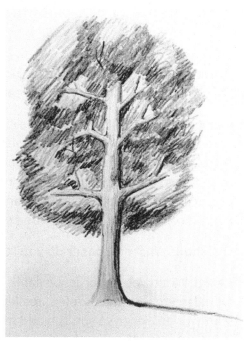

Artwork by Pamela Dowie

Question: I have always had difficulty drawing trees for some reason. It was a lot easier just doing more of a "scribble," but I'm still not sure about the final outcome. Any suggestions?

Reply: This shading looks great! As far as the drawing is concerned, the tufts of leaves appear very symmetrical. Try going for more asymmetry.

Question: Any suggestions?

Reply: Feel free to go outside of the lines of the original tree contour. The more uneven and asymmetrical the tree is drawn, the more realistic it appears. You have the basic dark and light areas down very well. I would add a little bit more medium tone to the light areas to make a gradual transition. Try some small circular motions to replicate the look of leaves from a distance.

Follow up: Again, thank you for your help! This is exciting to me, I find your lessons so informative, and your personal help in your replies. I'm looking forward to going back to my drawings to make changes.

Artwork by Tyna Williams

Question: What shape are you making with your pencil? I just did circles, but I'm wondering if I did it wrong? I really wish I could draw as well as you can.

Reply: I did use a bit of a back-and-forth motion as well as small circles. You didn't do it wrong! Whatever shapes or motions are comfortable for you is correct. If you find that the marks you made don't look right, you can always blend them in. Thank you for the compliment on my drawing skills. With practice, you will become more than satisfied with your own work. Remember, everyone can draw but no one can draw just like you.

Question: What size paper do you recommend?

Reply: Whatever paper is available to you is fine. Some people prefer to work large and others prefer smaller-scale drawings. It's a good practice to start working large so you can add more detail as needed.

Question: I'm drawing a tree from life, and the cast shadow seems to go in many different directions. Where should I put it?

Reply: When several light sources are present or not an obvious light source, the light and dark tones vary and are less predictable. This is especially evident when there is not one direct light source. This is seen especially in the cast shadows. The shadow will be darker in the area where another shadow

falls over it, usually closest to the stump area. Be aware of the sun's position in the sky and observe, drawing what you see.

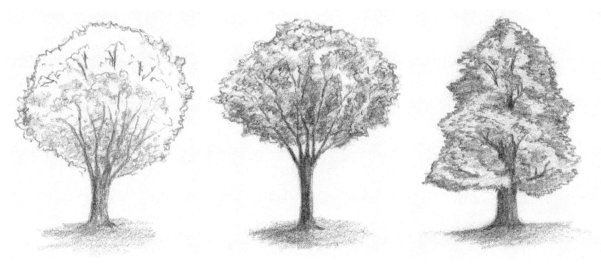

Artworks by Ivan Huska

Comments:

"The blob lesson helped me a lot when I was drawing my tree. I drew shaded blobs for my leaves, and they came out pretty good! Thank you!"

"I don't usually work in pencil, but I find that this course is really helping me to see form. I am starting to enjoy drawing and shading with pencil."

"I used to try and add individual leaves when drawing trees, but it was too tedious and didn't quite look right. I never realized that simplifying a tree can actually help a drawing to look more realistic."

"At first, I was a bit surprised at the simplicity of your suggestions, but then I realized that simplification is exactly what I needed to make my artwork look more believable."

CHAPTER EIGHT
GRADATIONS, HIGHLIGHTS, REFLECTIONS, AND BLENDING

Know:
• Gradation is a visual technique of gradually transitioning from one tone to another.
• Adding shade to a drawing introduces the third dimension of volume and depth
• Highlight, midtone, core shadow, reflected light, cast shadow

Understand:
• Knowing when to stop blending is beneficial to replicating realistic tones.
• Observing and replicating a definite light side and dark side of a rounded object helps to define the form of that object more accurately.
• A combination of reflections, gradations, highlights, and blending is crucial to shading an eye realistically.
• Several layers of tone can build into a smooth, realistic finish on an artwork.

Do:
• Practice creating gradations by varying pencil pressure or changing pencils to different grades to create a seamless change in tone.
• Observe and visually determine the placement of highlight, midtone, core shadow, reflected light, and cast shadow on a round object.
• Draw and shade a realistic human eye using the techniques provided to indicate shade, shadow, reflection, and highlight.

The way an artist blends and shades his or her drawings determines how realistic they will look. In this lesson, we will discuss gradations and highlights, adding reflections and how to approach blending without "over-blending" and flattening tones.

When we made our value scale it was important to have a clear ending and beginning of each different shade so we could create a grid that indicated specific tones within it. The first lesson where we applied our value scale to a five-toned image did not require any gradients, only solid tones. When shading realistically, an artist takes those various shades and blends them together so that they appear to seamlessly move into one another. This is called gradation. Instead of blocking in tones, a gradient gradually transitions from one tone to another by pressing somewhat hard with a pencil and letting up on the pressure gradually (or changing pencils grades) so the tone becomes steadily lighter and lighter.

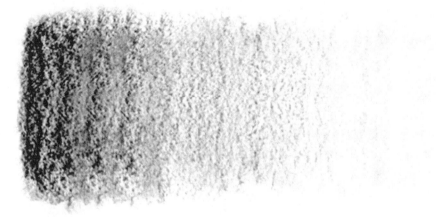

Here is an example of tones placed together in a gradation from dark to light. This was created using an 8B pencil of varying pressures, one way to create a seamless look. Notice that there is not one clear ending or beginning to each tone. An artist may want the gradation to appear smoother and blend the gradation tones. A tissue, finger, or blending stump tool, also known as a tortillon, can be used for this process. An artist will rub gently over the tones in a back-and-forth or circular motion to blend them into one another and smooth out any marks or voids that may stand out too much. When this is successfully done, the appearance of tones will still indicate a

gradual change from dark to light while combining any lines that stand out into one another. The tones will still be somewhat crisp as the dark tones effortlessly and seamlessly become lighter.

Knowing when to stop blending is crucial to replicating realistic tones. It is easy to blend too much, which is something an artist should avoid. Over-blending will remove some of the intensity of the darkness while taking away the brilliance of the lighter tones. This is where an artist runs into the danger of creating mud. The more blending that happens, the more muddled the shading can appear.

In the example above, the depth and dimension have disappeared from the gradation because it has been over-blended. The crisp tones that indicate darks and lights have become very similar to one another in a flat, undistinguishable gray tone. A good rule that I follow is to blend with your tool back and forth only two or three times. The fewer passes made over the tones reduce the chances of making mud. This may take some practice. When done correctly, gradation shading interprets an object more thoroughly through the representation of light, reflection, and shadow. Lines in an artwork can

only suggest so much. A simple line drawing can easily represent the appearance of two-dimensional objects showing width and height. To add shade to an object is to introduce the third dimension of volume and depth. Also, objects in real life do not have an outline around them, just a change of value. The same idea applies when drawing realistically; an artist shouldn't darken the outlines around what they are drawing. Instead, the shadows can be darkened and highlights added to create a dynamic artwork.

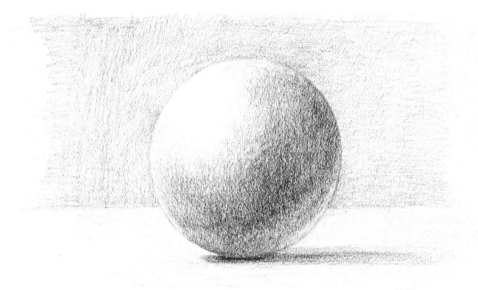

Let's take a look at this image of a sphere. This is a drawing of a white sphere on a white background. A sphere in a drawing is a two-dimensional circle showing width and height that is shaded in to create the illusion of form by adding depth. All of the highlights and shadows are depicted, along with and an obvious light source. Although this image has been drawn from a still life using a white sphere and white background, it is not interpreted as white but rather a series of tones and gradations. A spherical surface demonstrates an even flow of tone from light to dark. A cast shadow is created when the source of light is obstructed by the sphere.

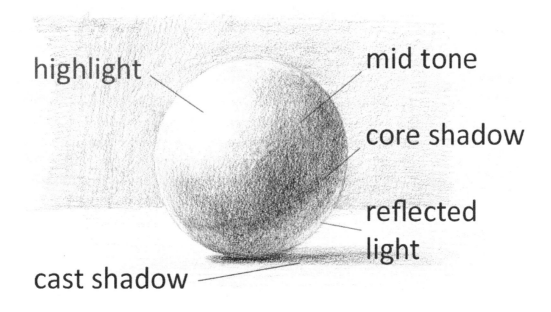

highlight

mid tone

core shadow

reflected light

cast shadow

When several light sources are present, the light and dark tones vary and are less predictable. To simplify this study of light and shadow in this first section, I have used only one light source. The lightest area or area where the light source directly hits is considered the highlight. There will be a highlight on an object if an obvious light source is involved. The second area to note would be the midtone. This is the area between highlight and the darkest area of your shaded object where the light is not directly hitting. It is still in close range of light source but not direct enough to be as bright as the highlight. This is where an artist would lay down a medium gray. The next area is the core shadow. This is going to be the darkest part of the shade itself, which receives the least amount of light from a light source. It is the darkest part of the sphere, and directly opposite from the light source. There is also a sliver of reflected light seen on the edge of the sphere that is in shadow. Reflected light is a faint rim of light that is reflected onto an object from the surfaces surrounding the object. Reflected light can brighten areas of the subject that are in shadow, and, in some circumstances, help to define it from its background or supporting surface. Without this bit of reflected light, the sphere would not be as defined and may appear flat. Finally, the cast shadow is added to reinforce the direction of the light source, further giving this circle the appearance of depth. When an object blocks a light source, it casts a shadow. A cast shadow varies value; the farther a cast shadow is from the object that casts it the lighter and softer and less defined its edges become.

Without the shading, this sphere is simply a circle. The gradation of tone, highlight, shadow, and contrast is what makes this two-dimensional circle into a three-dimensional appearing sphere. All of these shaded parts are necessary when shading.

The human eye is similar to that of the sphere in that it is a curved, not flat surface. In this next exercise, we will create a drawing of a human eye and shade it in realistically. Every eye is different. Some are more round than others, some more almond shaped, some have thicker eyelids and lashes, etc. This exercise will focus on a generic, all-purpose eye shape that can easily be adapted to use with any human eye likeness. As always, draw lightly so mistakes can be easily erased if needed.

The basic outline of the human eye is somewhat simple. Begin with a circle to represent the iris. The iris is the flat, colored, ring-shaped membrane behind the cornea of the eye. The iris is what people look at to determine someone's eye color. An artist may trace a circular object to help form the circle or draw it freehand.

In the center of the iris, trace or draw a smaller circle to represent the pupil. A pupil is an opening of the iris that appears as a black circle in a drawing. The size of this can vary and may change throughout the shading process, so don't be too concerned if it appears too large or too small just yet. Note: the pupil is always in the center of the iris; however, the iris is not always centered between the top and bottom eyelids. As an eye moves to look left or right, the pupil will always remain in the center of the iris.

Next, draw an arch that curves upward, partially through the top of the larger circle and then back down as shown. Think of the arch as a wide rainbow as you create it. This line will cover a portion of the iris so that it will not be seen in the final drawing. If you observe a human eye in person, you will notice that you will not see the entire iris on most people; a small portion of the top, bottom, (or both areas) of the iris is partially concealed by the eyelid. There are a few exceptions; however, most irises are partially concealed unless the eye is representing a shocked expression.

Note: The top of the circle that has been trimmed by the arch can serve as a good guideline for making the top part of the eyelid later.

Next, draw a line to represent the bottom lid. This line is slightly curved downward and then slightly touching the lower circle of the iris and then back upward to touch the edge of the upper arch.

Draw another curved line just below the lower lid to represent the thickness of skin there. If you look in the mirror closely at your eye and pull the lower area of skin downward, you notice a little ledge where the lower lashes sprout from. This line will represent that ledge. Draw it very lightly, as it will be barely visible (but necessary for a realistic representation) in the final artwork.

Finally, draw the thickness to the upper lid. This line will represent the crease in the skin seen above the eye when it is open. This line should be placed above the iris circle. The portion of the iris that is covered by the upper (or bottom) lid can be erased at this point. If you do not want to draw the eye and prefer to concentrate on the shading, use a copy of the outline provided above.

Add a small organic shape on the iris and/or pupil area to represent the reflection of the light source. The size and shape of the reflection can vary. Any overlap in the outlines will be erased or blended later. This is usually an organic shape and can appear in any spot on the pupil, iris, or both. This area will not be shaded in. Simply outline it and then avoid filling it in with shade. The white of the paper will be the brightest tone we have to work with, so try to keep white areas untouched by value. Highlights are one of the most crucial elements in drawing a realistic eye because they offer the illusion of light and life.

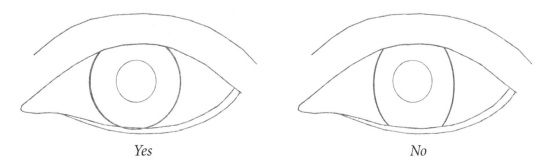

Yes *No*

Tip: When drawing a human eye, it helps to draw the round iris first then the skin around the eye as seen in this tutorial. When an eye is viewed straight on, it should be circular in shape. If the eye skin is drawn first, then the iris (which many artists do), it is tempting to draw the iris area as a parenthesis shape with curved lines, not an actual circle. The example on the left uses a circle to serve as the iris, which better represents a realistic human eye than the example on the right, which uses curved lines or a "parenthesis" to represent the iris.

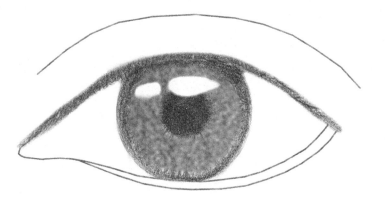

To begin shading, start with the dark areas first. This includes the iris, pupil, and upper lash line. With a quick back-and-forth motion or light scribbling motion, fill these areas in. I usually go right for the pupil, filling in the circle with a 6B or 8B pencil, making sure not to press too hard. The darkest areas will eventually be filled in with more layers of tone; however, keeping them on the lighter side when first beginning is a good practice. Once the pupil—the darkest appearing part of the eye—is filled in, the darkening and thickening of the upper lash line should be next, followed by the iris. This tone of the iris should be lighter than the pupil, translated with pencil into a medium gray tone. This will become more detailed later too. It is good practice to fill in all of the dark and midtone areas to dull the bright white of the paper. A quick lay down of tone all over can help the artist to visualize the eye quickly and helps to create contrast against the areas that will remain white. Also, avoid shading in the area that will eventually be the highlight. This highlight/reflection is going to make this eye look even more realistic. If you have any kind of reflection or light hitting the eye, it will appear as a white spot representing the shine or highlight. This can appear very simplified if working from a photograph where a flash was used. Natural light offers more depth and information in the eye. Make a conscious note of the shape of the highlights. The shape may differ in each eye and may partially obscure the iris or pupil.

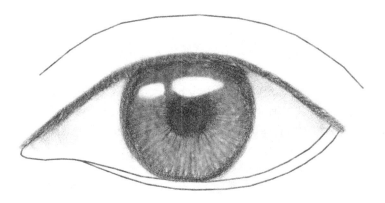

The ring around the iris has been slightly darkened, a light shadow cast from the upper lid has been added, and some spokes radiating around the pupil have been drawn.

This is the first layer of shade added to the eye. More detail can now gradually be added. The pupil can be darkened as well as the round edges of the iris, adding deep tones that gradually become lighter as they move toward the pupil. A ring of darkness around the iris adds depth to the sphere shape and helps the eye to stand out. The top portion of the iris directly under the lid should be a little bit darker to indicate the lid is a thickness above the eye, leaving part of it in shadow. The area of the white of the eye (the sclera), directly under the eyelid can also be darkened to a light to medium gray tone to indicate the shadow cast by the eyelid. Back to the iris: if you have ever looked closely at you own eye in the mirror, you will notice that it is not one solid, flat color. There are many different beautiful colors, radiating around the pupil in spokes of light and shade. These colors are like rays bursting from each curve of the pupil toward the outer edge of the iris. An artist should translate those colors into multi-shades of gray and indicate that detail in their drawing. With lines, draw some spokes radiating from the center of the pupil that stretch across the iris, similar to spokes on a bicycle wheel or rays of sunshine. Make another layer of spokes curving around, some short and some long. These lines should make the circle of the pupil become less perfect as the dark tones are pulled out into the iris in some places. Try to avoid outlining parts of the eye but instead define them with shade. Before the next layering of shade is placed, the current tones can be blended a bit. Using the blending tool of your choice, smooth out the rougher lines around the lash line area out toward the outer lid and combine the tones in the iris. This initial blending is to smooth out some lines so that the marks don't seem harsh. I prefer to use a finger for blending these areas as opposed to the tortillon or stump.

These paper blending tools can sometimes make the artwork too smudgy, especially when it has already picked up a lot of pigment and has become dirty. In my opinion, a well-used tortillon offers less control than your cleaner finger. Some artists might argue the opposite and state that an artist should never use a finger for blending, as they believe that the oils from your fingers will offer less control. Whatever you chose to use as a blending tool, do not over-blend. Too much blending dampens the luster and crispness of the lines drawn and flattens the gradations in tone. Keep blending to a minimum.

Once the marks have been smoothed to your liking, go back in and add another layer of tone with the pencil. Each layer will darken the darker areas with every pass. These dark tones, by comparison, are making the light areas stand out more as well. Beautiful contrast and interest is created when deep darks and light highlights are used in a work.

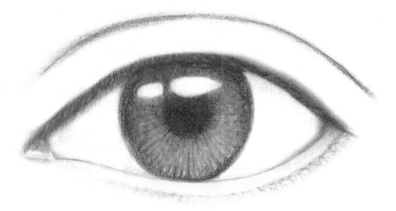

Next, concentrate on adding some shade to both the upper and lower lid areas as well as the sclera, the white part of the eye. Dab at the lower lid thickness with the kneaded eraser to lighten the pencil lines a bit. We want to remove some of pigment so it will blend into the shading without a harsh outline. Add a light gray shadow with a 2B or 4B pencil that curves around the edge of the base as shown, getting lighter and lighter until the shade disappears near the tear duct area. In contrast, the folds of the upper eyelid should be slightly darker. This fold is not within the direct light, so it will appear darker than the lower lid. A thin band of light gray tone should be added to the upper crease and then slightly blended to reduce the harshness of the line.

When re-creating the part of the eye that we consider to be white, we will actually be adding shades of light-gray and mid-gray tones. The outer corners to the left and right of the iris should have some tone that gradually gets lighter toward the iris. This will help the eye to appear round and spherical, not flat. Finally, the rounded triangle tear duct area can be blocked in with a light shade of gray, leaving a bit of highlight at the bottom of it.

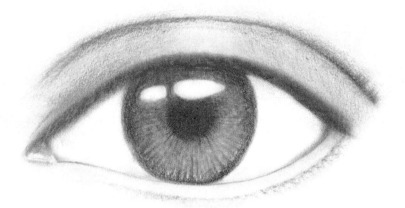

Next, add a layer of shade to the upper eyelid. This light to medium gray tone should fill the area from the upper crease to the top of the eye curve. The center of this area (highest point of the arch) can be slightly lighter to indicate a subtle highlight. In turn, the upper lash line can be made a bit thicker as well.

Layer by layer, the artwork is gradually becoming more detailed. The creation of this eye, or any detailed object, will not offer the artist immediate completion or instant gratification. Drawing and shading realistically is a time-consuming process involving layers of shade and keen observation. Creating artwork is a process resulting in a likeness that eventually develops over time.

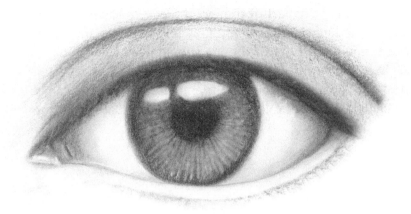

Add more detail and contrast to the tear duct area and sclera. The sclera can be darkened near the corners to further reinforce the roundness of the eye.

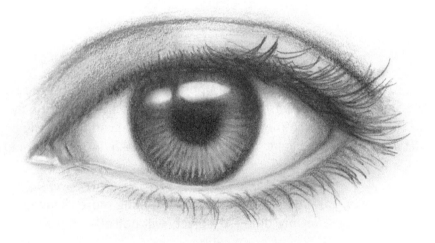

The eyelashes should be drawn after most of the shading is complete. If the lashes are added before the shading process, the fine hair lines will disappear as tones are blended in. Be cautious when considering this detail: draw them lightly at first; notice the direction in which the lashes have been drawn in this example or look at your own eyelashes in the mirror. The lashes above the eye grow out and up around the lid and are angled in a variety of directions. Make note of the length and direction for a realistic representation. Usually, eyelashes are longer on the upper lid and shorter on the bottom. The outer edge of the eye (the area farther from the nose) on both the upper and lower lids will also have longer hairs. The lashes can be blended with a pass or two of the finger so the individual hairs are not as prominent. An artist can also add more spokes on the iris by reshaping the eraser into a lean wedge and erasing small slivers in between the spokes to

replicate flecks of light in the eye. Blend the tones once again for a smooth, glassy appearance; just be wary of making mud. Smudging too much will dull the vibrancy of the work and cloud the contrasting tones. There should be a distinct difference between the lights and the darks, especially around the highlighted area; however, they should be blended into one another. In reality, objects in natural light rarely have crisp, dark outlines followed by extreme, sudden white (except in instances of severe contrast).

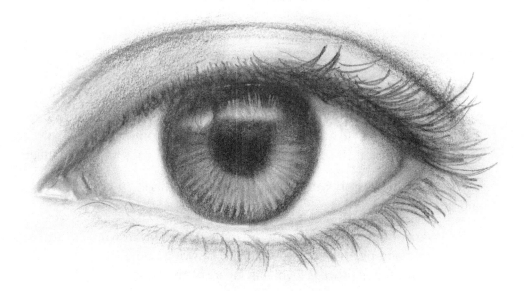

The highlight may have become darkened a bit from all of the blending and shading we have been doing. To make the highlight stand out, an artist may need to erase some of the pigment in the blank area we originally set aside for this area. If you have pressed hard with your pencil over this designated area, erasing marks with the kneaded eraser may be difficult. A regular rubber eraser can be used if the kneaded one isn't working as well. The spot where the shine should be is up to the artist if they are drawing from memory. If drawing from life, observe where the shine is and replicate what you see. The highlight can be seen in many different places but is usually most prominent in the pupil or the iris. Sometimes there is also a shine on the sclera. Take care to add highlights since drawings of eyes with an intense shine tend to be more striking and interesting. I have darkened the area around the erased spot so the shine appears even lighter. To add another level of detail, reflections can often be seen in the highlights of the eyes. Eyes can reflect images and objects that a person sees, and some artists choose to add these reflections to their artworks for a truly exceptional drawing. Fine veins seen within the eye can also be added. I have added a reflection of the eyelashes in the highlight. This has shrunk the highlight a bit

but enough is still seen to keep it dynamic and interesting. The eye is complete when the artist is happy with the result. This may mean that several layers of tone need to be added, or some the pigment needs to be removed. A combination of reflections, gradations, highlights, and blending is crucial to shading an eye realistically. It takes time, patience, and many shades to create a realistic human eye.

Things to remember when shading your eye:

• Begin with a circle shape, then draw the eye skin around it. Beware of drawing a "parenthesis" inside your eye, as it may not look as realistic.

• Draw all of the basic lines of the eye shape before beginning to shade.

• Outline a small organic shape on the iris and/or pupil area to represent the reflection of the light. This shape can change from eye to eye and will eventually represent the shape of the source of light causing that highlight.

• To begin shading, start with the dark areas first. This includes the iris, pupil, and upper lash line.

• Use layers of tone to create your drawing. Do not lay down all of the tone on one area and not revisit it to refine it. Drawing and shading realistically is a time-consuming process involving layers of shade and keen observation. Creating artwork is a process resulting in a likeness that eventually develops over time.

• An eye is a curved surface. Subtle shadows and highlights should be added to indicate this.

• An artist can also add more spokes on the iris by reshaping the eraser into a lean wedge and erasing small slivers in between the spokes to replicate flecks of light in the eye.

• The eyelashes should be drawn after most of the shading is complete. Notice the direction in which the lashes have been drawn in this example or look at your own eyelashes in the mirror. The lashes above the eye grow out and up around the lid and are angled in a variety of directions. Make note of the length and direction for a realistic representation.

• Reflections can be added to the highlights within an eye for even more detail.

• To boost the brightness of the highlight area, an artist can lightly shade over the remainder of the drawing to dull the white content. That will ensure that the main eye highlight is the brightest part of the image.

When using the image in this book as inspiration: Remember that every eye shape is different. The example in this exercise is a generic, all-purpose eye shape that can easily be adapted to use to replicate the likeness of any human eye.

When drawing from life: Try taking a close-up photo of an eye using various natural light sources (no flash). This will provide interesting highlights and contrasts. You could even try placing an object in front of the light source to create an image that can be reflected in the highlight of the drawn eye.

Try to use as many shades as possible when drawing eyes. Don't be afraid to make dark marks and shades, since contrast can be the deciding effect as to whether an artwork looks realistic or not. I used to be concerned about making areas too dark because they wouldn't be easy to erase. Because of this, my shading looked incomplete, and I wasn't satisfied with the outcome. Don't be afraid to make use of those soft (B) pencils and darken those dark areas a bit more. You won't ruin your artwork; you will be taking a step toward becoming a stronger artist as you learn how to manipulate shades to create more realistic artworks.

Examples, Questions, and Comments

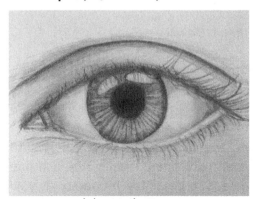

Artwork by Naila Dautova

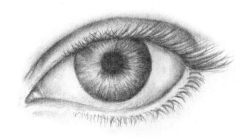

Artwork by Jay Costello

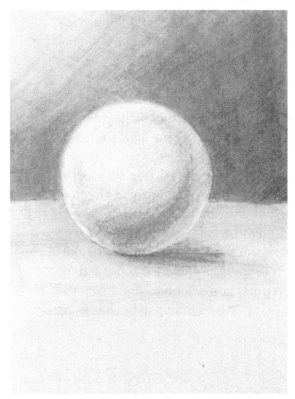
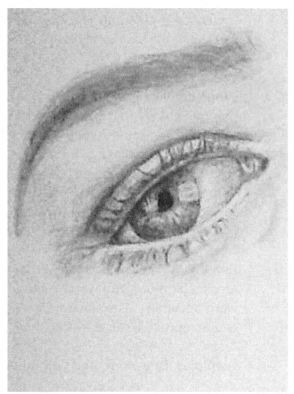

Artworks by Pamela Dowie

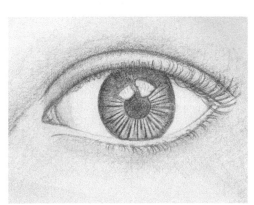

Artwork by Tamara Eden

Question: I had a blast with this lesson. Any critique on my drawing?

Reply: This is a great start! You have described the direction of the lash growth very well with lines. I think the lash line area needs to be a little bit darker as well as the pupil area. Blending of the "spokes" can help them to appear subtler while the addition of some light tones and blending to the corners of the sclera will round out the eye to appear more spherical.

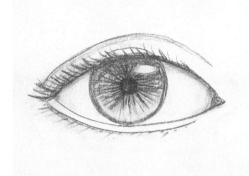

Question: I feel like my eye looks too cartoon-like. How can I make it more realistic?

Reply: This is a great eye sketch. The shading is starting to come together to add depth and interest, and the highlight really captures my attention. The cartoon-like part that I think you are referring to is the dark outlines that are defining the eye shape, specifically the thickness on the bottom lid.

It is not necessary to add dark outlines to make features stand out; that is what the shading is for. A realistic drawing does not have outlines around it, just like objects in real life do not have outlines. Artists instead chose to change the values of an objects edge. Instead of using dark outlines, fill in your eye with shade details. Some parts of the drawing might even disappear completely and have no edge to define them. This is okay because if you step back and look at it, your brain will oftentimes "fill in the void," understanding what the object is without seeing all of it. In this case, the old saying "less is more" holds true.

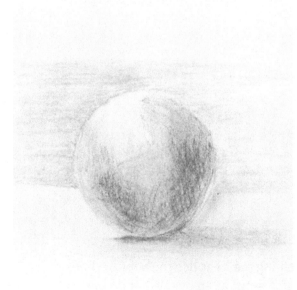

Question: I made it muddy, didn't I?

Reply: Some of the midtone area may be over-blended a bit; however, the form shadow (the less defined dark side on the sphere not facing the light source) should have a softer, less defined edge. The changes in form shadows require careful observation to determine what value it should be in comparison to the surrounding values. The highlight is spot on!

Artwork by Tyna Williams

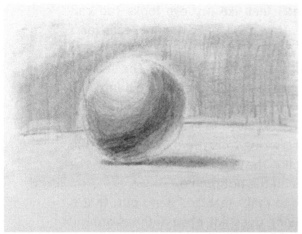

Artwork by Whitney Krug

Question: Here is my sphere. Do you think it ended up a little bit squashed? I also made one really quickly with watercolor, and it turned out better than I expected.

Reply: Don't be too concerned about the shape. The range of tones in the shading is a great start. The curvature of the pencil lines and obvious highlight, midtone, and core shadow are believable. I am glad you are trying new mediums and gaining confidence in your work! Having fun and enjoying the process is an important part of making art.

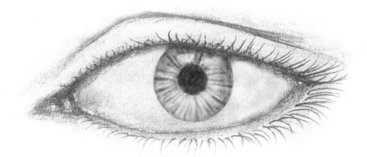

Artwork by Pierre S.

Question: I am enjoying this class. It is helping me to notice the subtler shading in everything I look at. This is my first attempt at an eye. What do I need focus on to improve?

Reply: This looks great. The subtle shading you placed on the sclera (white part) reinforces the spherical look. One thing that stands out is the sizing of the iris. If you make it a bit larger, there will be less white space and the eye

112

will look more realistic. Take a look at your own eye in the mirror. You will see that the iris and pupil make up the bulk of the eye.

Follow up: Thank you, I do still have some difficulty in seeing how things are in relation to one and other. This class has really helped with my perception of shading and contrast; it's becoming something I am more aware of when deciding on a subject to draw.

Question: My question concerns reflective light. I am assuming objects that are spheres, cones, or cylinder in shape will have reflective light because they all have a rounded shape. Do cubed objects have reflective light?

Reply: Yes. Reflective light is light that reflects from surfaces of objects or parts of a drawing onto other surfaces surrounding the object. This can happen whether an object is rounded or flat. Reflected light will have no effect on a surface that is illuminated by direct sunlight, only in shadow.

Question: Should I blend a little as I go, or draw a lot, then blend it all at once?

Reply: This is personal preference; however, I believe you will get the best results if you add tone, blend, and repeat. I like to blend a little as I go when I see that tones are becoming too separate from one another or individual marks stand out too much when I want a smoother look. Blending as you go also helps the artist to visualize the final product sooner. Layering your tones and perfecting them is a process that should happen gradually.

Question: I don't have a tortillon. Do you think a rolled-up paper towel would work?

Reply: It's personal preference. I actually use my fingers sometimes for blending. A lot of artists think that is not proper because the oils on the finger can change the properties of the tone. I think that whatever you have available and what you are comfortable with is what you should use!

Question: I am having a hard time seeing midtones on my practice sphere. What should I do?

Reply: The darks and the lights are easy to see; it's the middle tones on either side that confuse the artist's eye when deciphering value relationships. To help find the midtones, it helps to keep the values on the light side very light and the values on the dark side much darker. The edge of your sphere where it is blocked from the light source is going to be the darkest value or the core. The core value will blend into the middle tones from the shadow edge toward the lighter tones. This is the area that is your midtone.

Question: I'm struggling with the eyelashes. Any tips?

Reply: Eyelashes can be very challenging to draw because there are so many of them. If you observe just a section at a time, they will become easier to replicate. Upper lashes often grow down a short distance before swooping downward, then upward. The angle that the eye is viewed at will depend on the way the lashes are seen. A straight-on view, like the one in this tutorial, use foreshortening. This is a technique used to make an object appear closer than it is or as have less depth or distance. Try looking at the eyelash as a shape or curved line, not as an eyelash. Copy the direction and placement of the line. Try not to think of it as an eyelash but just as a curved line. It will be easier to re-create. Start at the upper edge of the eyelid, curve your pencil downward a bit, then curve it upward. The line should be thinner and lighter near the tip of the lash, so use less pressure for this area. Also notice the length of each lash varies depending on where it is growing from. Lashes around the outer edges of an eye tend to be longer than those closer to the center of the face. Look at images of eyes or even your own eye in a mirror. This will help you learn more about creating a likeness.

Question: Is the line around my iris too dark?

Reply: It is not too thick; however, it is an outline. Keep in mind you don't really want to have lines to define the edge of something when you are shading. Use your current lines to blend the various tones of the iris into one another so there is a gradual change. The rim of the iris can be a bit darker than the rest of the iris in some cases. Regardless, the rim should still have a smooth transition into the remainder of the iris. Try a little blending. You can always add more tone to define the edge if you blend too much.

Question: How do you draw a picture where part of it is blurred?

Reply: The blurring you're talking about sounds like blending, which is the technique of gradating value and tone. Some artists are strongly opposed to smudging with fingers and prefer to achieve blurring by laying down a series of tone, varying pressure and pencil grade. Tortillons give you much more precision over blending than fingers. For a very blurry effect, you may want to practice blending the object you want to be blurred into the background over the edges of the actual object, deleting all but a hint of the object's edge. This can help to create an extreme out-of-focus effect.

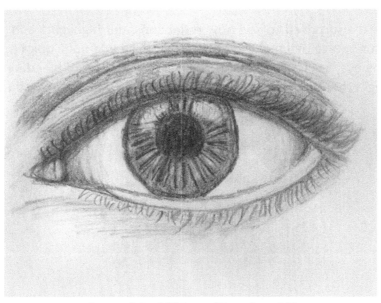

Artwork by Whitney Krug (age 12)

Question: This is my eye. I think the pupil is slightly too large, but still works. My eyelashes probably need some work, but overall, I'm happy with it. What do you think?

Reply: You did great! You have added some tones in the right places to make it appear more realistic. The size of the pupil is not too large because human pupils shrink and enlarge in real life as needed. The lashes are usually sparser as they get near the inner corner of the eye, but overall I'm happy with it too!

Comments:

"I haven't attempted the eye yet, but I know that the lashes are going to be hard for me. Mostly the direction and getting it without overlapping too much, and making the dark areas too black. I also have trouble with spheres. This is going to be a hard lesson! I am working on shading a sphere, and I think that will help me to show roundness of the eye. I am seeing areas of shade that I wouldn't normally notice."

"I think the eye project was a breakthrough for me! My shading looks more realistic, and I have learned a lot about the parts of a shadow. I love the way that a pencil drawing can be a finished piece of art."

"I was really surprised to see how reflections and highlights add finishing touches to my eye that make it look so realistic. It was not a quick process to create my eye, as I had to add lots of layers and do lots of blending to make it look right, but it all came together in the end. I am very pleased with my eye!"

CHAPTER NINE
SHADING WITH PEN

Know:
• A range of tones can be used to shade in an artwork using pen techniques.

Understand:
• When using most types of pen, the placement of marks, whether layered on top of one another, close together, or far away from one another, determines value, not pressure.
• Hatching, crosshatching, scumbling, and stippling techniques offer a different way to offer the illusion of depth and form.

Do:
• Practice shading with pen by creating a value scale using learned techniques to indicate a gradual change in tone from light to dark.
• Draw and shade a simple image using hatching, crosshatching, scumbling, and stippling techniques to indicate shadow and highlight.

Shading isn't just for pencils! A range of tones can be created using a pen as well. Hatching, crosshatching, and stippling techniques offer a different way to offer the illusion of depth and form. The basic drawing techniques for creating value when drawing with pen involves the same criteria for creating a dynamic and realistic drawing as with pencil. Creating dense darks and bright highlights are at the forefront; however, the way these results come about is where the difference lies. With pencil, an artist can apply a variety of tones by increasing or decreasing the pressure of the pencil marks or by blending marks into one another. When using most types of pen, the

pressure technique cannot be used to create value. Instead, the placement of marks, whether layered on top of one another, close together, or far away from one another, determines value. There are many wonderful ways to shade with pen, and we will discuss a few of the most popular techniques that are considered to be the standard for drawing with pen and ink.

Types of pens: There are variety of different types of pens that can be used for drawing. The kind of pen an artist prefers depends on the type of line or mark he or she would like to create. The thickness, thinness, or regularity a pen an artist uses should be chosen according to the type of art he or she wants to create, in terms of style, subject, and mood. Each type of pen will result in a different quality of line. Traditional ink drawing pens have interchangeable tips (nibs) that hold ink. The nib is dipped in to a container of ink and then used to draw with. Graphic or technical pens come with a shaft filled with ink and have various tips that produce a variety of lines. These pens can be re-fillable or disposable. Some pens feature a brush tip that is best used to vary the type of line made with one stroke. Artists even use ballpoint pens to draw with. Any of these types of pens can be used to create fine art!

The crispness of pen can add fine details and sharp contrast to any drawing, offering a clean, finished appearance. Plus, having the skills to shade using this medium will further enhance your knowledge as a skilled artist. Most pen drawings are completed with black ink on a white surface, leading to heavy contrast in value.

Hatching is one of the most basic techniques that can be used when shading with pen. Hatching is a term used to describe non-crossing lines that are placed near one another to indicate the value on or around an object to create the appearance of depth and volume. The distance between the lines and the thickness of the line offers different effects. Marks that are close together will appear as areas of darkness, while marks that are farther apart will read as light. The cube above is an example of parallel hatching: rows of parallel lines placed closely together. The lines in this example happen to be vertical; however, parallel hatching can be horizontal, diagonal, etc. Notice

that the hatch marks on the side that appears darker are closer together while the marks on the side that appear lighter are farther apart.

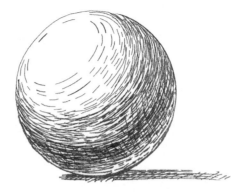

When shading objects that do not have flat plains, contour hatching can be used. Contour hatching is when hatching lines follow the contours of the subject. In the example above, the hatch marks follow the curves of the sphere. This method of hatching greatly enhances the sense of depth in a drawing as well as shows value. Surfaces that are not flat should be shaded using contour hatching for a more realistic appearance.

Crosshatching is the same as hatching with the addition of another layer of line placed on top, usually in a perpendicular direction to the first set, creating marks that have a series of intersecting parallel lines. Crosshatching lines that are placed close together will read as dark, while lines placed farther apart will appear as light in a drawing. This process is one of the quickest and most effective ways to create value with pen. It can be applied as straight lines as well as follow the contour of the subject.

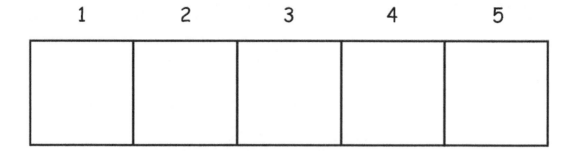

| 1 | 2 | 3 | 4 | 5 |

Let's practice by creating another value scale, this time using pen. Using an empty grid of five boxes, we will progressively start to fill each box with shade using a series of lines moving from light to dark. When you increase the density of a collection of hatch marks, the area will appear darker, which can be useful for creating value variations. There can be thousands of tones that can be created; we are just going to make five. Pen is the preferred tool for using this method; however, pencil can be used as well. If using pencil, make sure that it's very sharp; otherwise, the lines can be drawn with a soft edge and may appear to be too close together, and the white space in between won't be as visible.

Beginning with the hatching technique, fill the first box (labeled 1) with a series of equally spaced lines. The idea is to not cross them; keep them parallel and somewhat far apart from one another so that the tone appears to be light when viewed from a distance.

The second box can be filled with lines that are slightly closer together so that they appear darker than box 1 in tone when viewed from a distance. Note that these lines can be drawn in any direction: horizontal, vertical, diagonal, or otherwise; the direction does not matter as long as it is consistent. I like to place my lines diagonally, but they can certainly be drawn in any direction. Whichever direction pleases the artist is the direction to choose.

The third box should have lines that are much closer together than the ones drawn in box 2. Even tighter, these lines can be so close together that they are almost (but not quite) touching. The tones in this box should appear much darker than those drawn in box 2.

In box 4, draw tight, parallel hatch lines with the addition of crosshatched lines to indicate a darker value than box 3. Since the lines created in box

3 are placed so close together, the only solution to make the tone appear darker is to cross the lines. Lay down the first layer of lines moving in one direction, followed by another series of lines on top moving in the opposite direction. The pen used for this tutorial is a very fine pen, so any drawing or value scale made with this pen will require many lines to achieve a realistic look. Use whatever thickness of pen you're most comfortable with to get the desired results.

The last box of this value scale should be the darkest of them all, without actually coloring it in solid. To get this dense dark, draw several layers of line to achieve the desired tone. Lay down the first few layers of parallel lines, then go over it again with crosshatching. If it doesn't appear darker than the tone created in box 4, add another layer of crosshatching over it. There should be a considerable difference between the light and dark tones created on the whole scale when viewed from left to right.

The whitespace defines how these tones appear from a distance. When applying this technique to a drawing, an artist may choose to use cross-contour lines, parallel lines, or both when adding tones with pen.

Another technique used when shading with pen is stippling. Stippling is a series of dots placed close to one another to create the illusion of depth and form. The closer the dots are to one another, the darker the area will appear.

The points are placed farther apart from one another where the tone should be less intense or lighter. You can adjust the depth of tone and the roughness of texture by varying the density and distribution of the stipples. This is probably the most time-consuming of all of the pen shading methods. The technique known as pointillism is not the same as stippling. To shade with stipple, carefully lift and press your pen (or other utensil) onto your sheet of paper to create small point.

> *Pointillism uses points of color placed very close to one another to create an illusion called optical mixing where two small amounts of different colors laid down side by side appear to create a different color. The technique relies on the ability of the eye and mind of the viewer to blend the color spots into a fuller range of tones.*

Let's create another value scale using the stippling technique. Before I begin, I usually place my wrist on the table or whatever surface I am working on (as opposed to holding it up in the air). Anchoring your wrist is helpful when creating consistent marks on the paper. If an artist holds their hand and arm up while attempting to stipple, the dots will not be as neat or specifically placed, and dash marks are more likely to be made instead of dots. Give yourself a rest and help your artwork in the process by resting your wrist.

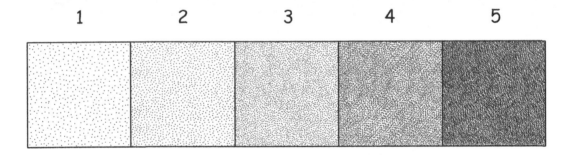

The first box of the stipple value scale should represent the appearance of a light tone, so the stipples should be placed far apart from one another. When this is done correctly, a very light tone is what will be perceived when it is viewed from a distance. The second box will have stipples that are slightly closer together. The process of stippling takes care and effort; however, once an artist has some practice doing the gesture of stippling, he or she can act like a machine and easily replicate the motion over and over. Don't try to speed up the process if you are not comfortable with it. Make sure the stipples are somewhat evenly spaced and that actual dots are being made, not stroke lines. The process can get tedious, so take a break if you feel like

you are getting sloppy. Frequent breaks will help the wrist to recover and will also give the artist an opportunity to step back from the work and look at it from a distance. For box 3, continue filling in the value scale, progressively making the dots closer together. Box 4 should have dots closer together than those made in box 3, while box 5 should have dots closer together than those made in box 4. As the dots are placed very close together to create very dark tones, it is likely that they will overlap or touch, which is acceptable and inevitable.

Once the value scale is complete, step back and notice how each box is visibly different from one another; the stipples that have been placed farther apart appear to have a lighter tone while the stipples that are closer together have a dense, darker appearance. The same values that we are creating with this value scale can be followed when creating a drawing using the stippling technique. Note that all of the dots created are the same size and shape; they just appear to create different shades when placed closer or farther apart from one another.

> **Tips:** *For a polished-looking drawing, make sure the dots are actual dots, not dashed lines. It is easy to accidentally make dashed lines while stippling. An artist can get tired using this method or may try to stipple quickly, which can result in a mark other than a dot. Also, try to keep all of the stipples evenly spaced. An artist can vary the placement of dots a bit in areas consisting of the same tone, but the finished artwork will look more attractive if the dots are evenly spaced according to the tones they are representing.*

Hatching, crosshatching, and stippling techniques can offer a range of values. Let's apply those techniques to a drawing so we can see them in action. Let's begin by stippling a drawing of a pear.

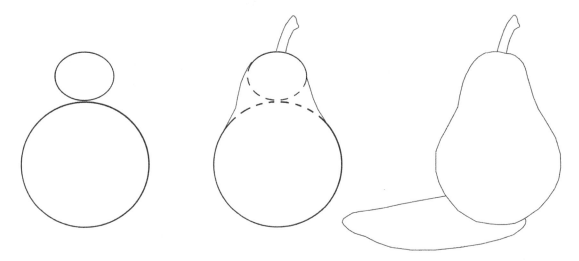

Start by drawing or finding a simple outline of a pear with a cast shadow outline. A pear can be drawn using simple shapes combined to create an organic form as seen above. This will be the basic shape used for adding a variety of tones so that it has the appearance of form with depth. Preliminary drawings should be created using a light pencil line, then filled in using pen. When the ink has dried, the graphite of the pencil can be erased, leaving a crisp, shaded image.

For this lesson, I will be using a fine-point marker pen. The tip is very fine, and I will need to make many dots in order to lay down a believable tone. The higher the density of dots, the more time it will take to re-create a realistically shaded image. If you don't want to put a lot of time into stippling an image, a thicker-pointed pen or marker will leave a wider stipple. Thicker pen tips (nibs) can be used and involve less time when stippling; however, the finished artwork will not appear as detailed. For a more refined drawing, use a fine pen with a thinner tip.

Begin by adding the darkest values of the pear first. These areas are the ones farthest from the light source. Start in the dark area and begin adding closely spaced dots. Do not make the value as dark as it can be just yet. Rest your wrist on the paper to avoid fatigue and to ensure a clean stipple. Be sure to NOT rest your wrist on an area of the drawing that is wet with ink. Allow any marks to dry before touching them to avoid smearing. When shading with pencil, it is wise to shade the dark areas lightly at first and then make them darker later on. This same principle is especially crucial when shading with pen. Mistakes cannot be erased when using permanent pen and liquid paper or Wite-Out is not an option, as it will make an area of the drawing stand out, highlighting a mistake. Be cautious when placing your initial tones and make them lighter than you think they need to be to begin with. Sometimes stippling projects can take hours, days, or even weeks depending on what it is that you are drawing. Make sure you're comfortable and when you need a break, definitely take it. If you feel like you are getting sloppy or rushing your work, stop for a break.

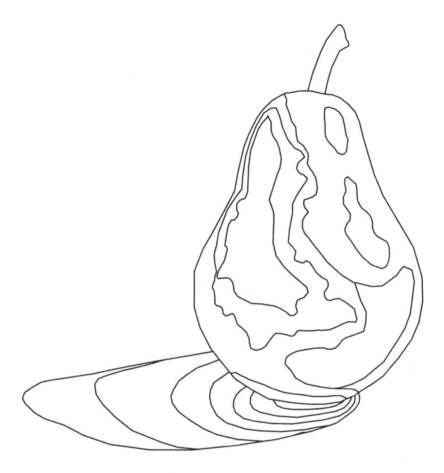

Choose a starting point to begin stippling. It is helpful to observe the object or item you plan to stipple, either from life or a photo. Although an artist can certainly create a stippled drawing from imagination, results of stippling are usually more successful when using a reference to examine as they draw. Look at the areas that are darkest and the areas that are lightest. Mark each major change in tone on your drawing with an outline. Do this in pencil to avoid any outlines in the final artwork. Light pencil lines can be erased when the pen has dried. These lines will serve as guidelines for the variety of tones we will place on the pear. The above image has many areas outlined to serve as a placeholder for where the dark and light tones will be placed. This is only one of the many ways an artist can stipple. Some artists prefer to stipple a light tone of dots all over their drawing to begin, then later going back to make areas darker as needed. Some artists prefer to put patches of dots in one area and work outward from there. Other artists start with the darkest point and then work around the image to fill in all the dark areas. I will illustrate the latter by choosing the darkest point on my drawing to start with. There is no specific rule to creating with pointillism; it is the personal preference of the artist.

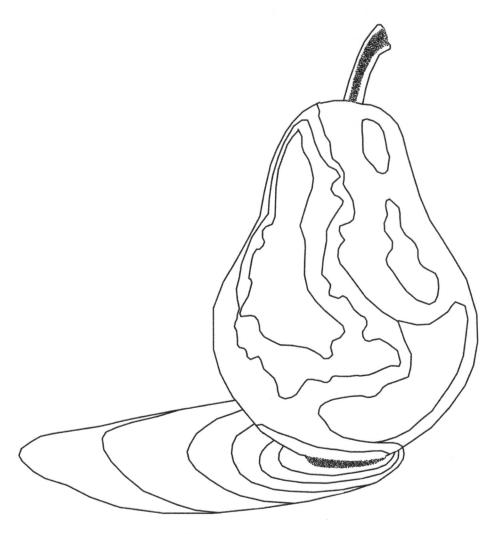

Begin stippling. Carefully lift and press the pen onto the area of the paper where the tone will be the darkest. On this illustration, the darkest area of tone is near the base of the pear and on the stem. These tiny dots are evenly spaced and close together so that they will appear to be a solid tone when viewed from a distance. An artwork that is done with stipple is made to be viewed from a distance so all of the fine dots will appear to blend in with one another into a gradation of tones. Taking my time, I have placed the dots evenly in the dark area. There is not any right or wrong way to go about doing this as long as the placement of dots appears evenly spaced.

Once you are done with the darkest areas of shade, move to stipple the areas that are just slightly lighter than that darkest area you just created. This layer of stipple should be just slightly farther apart than those created in the first layer for a subtly lighter tone. Keep looking at the reference image to discern the placement of each tone.

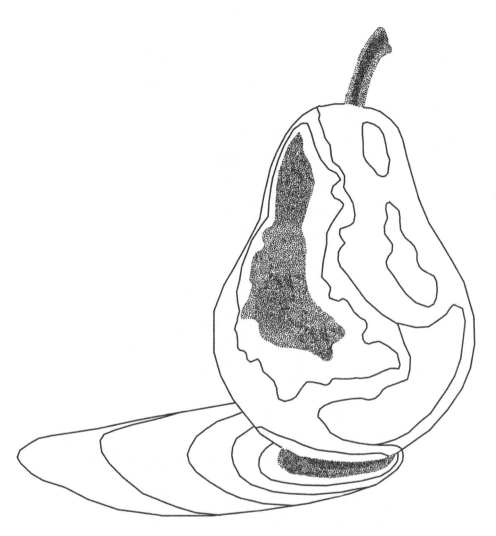

This step shows the next layer of tone placed on the pear, stem, and in the shadow areas. The tone appears slightly lighter than the previous area of tone.

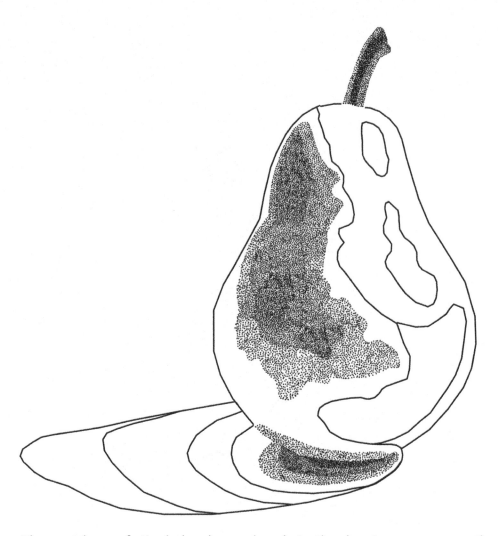

The next layer of stipple has been placed. As the drawing progresses, the pear should appear to get lighter in tone as the shaded areas move closer to the light source.

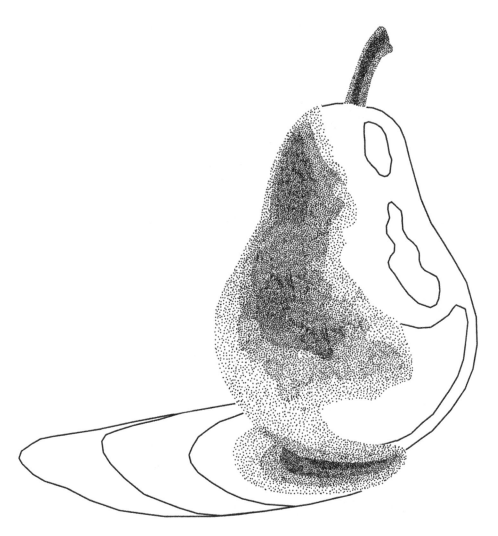

The next, less dense layer of stipple has been placed. Remember that you are not outlining each section of tone with stipple but rather subtly changing value to create a blend. The outlines shown in this tutorial are only guidelines to follow for putting areas of varying stipple. If guidelines are drawn on your artwork to separate areas of varying shade, they should be lightly drawn and erasable.

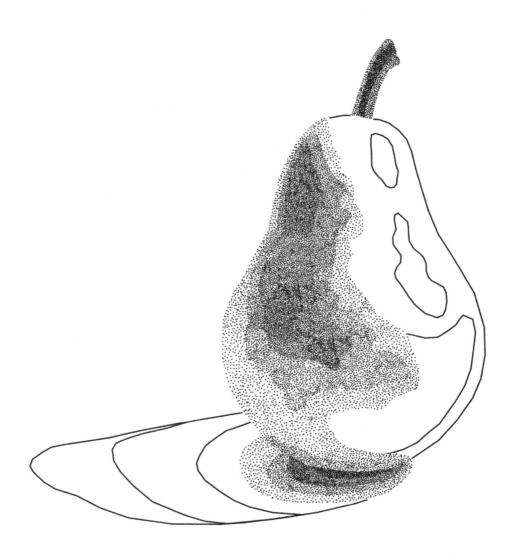

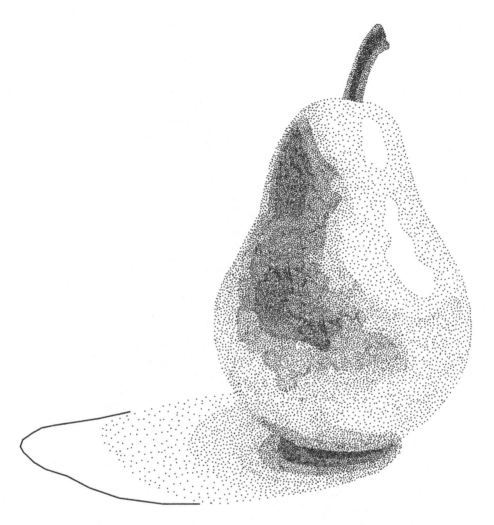

After laying down the initial layers of stipple, step back to observe the art-work to see if any areas needed to be darker. Areas can be made darker, but not lighter; therefore, it is important to stipple sparsely at first. After viewing this artwork, I noticed that the tones created above appear very choppy and need to transition more smoothly into one another. To remedy this, I went back over the stippled areas and added more dots in between each tone to form a gradation, removing the rough appearance.

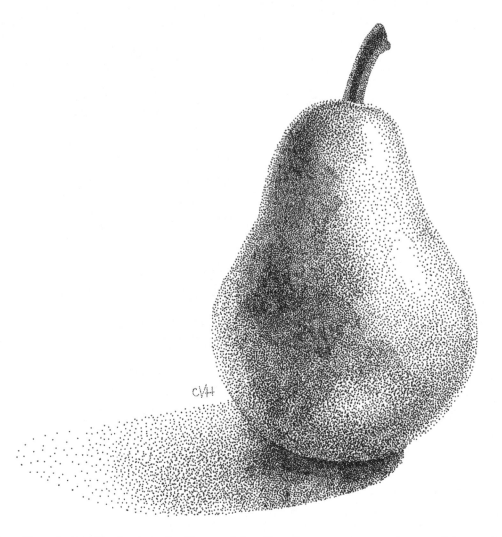

Here is the final artwork after revising the choppy areas and smoothing out the tone. Most areas appear to transition smoothly in to one another to create a realistic presentation when viewed from a distance. Stippling can be time consuming depending on the size and detail of the project. Viewing an artwork in progress from a distance frequently can help an artist to visualize the artwork as a whole, not just one tiny area that is being focused on. Take a step back and look at your work from afar. The goal of stippling is to create shapes and figures at a distance, not just close-up. If the stippling is dense, the dots should look like shapes that were drawn when viewed from a distance. Stepping back and squinting at your artwork is a technique that can be successful to define the tones by blurring and simplifying them. I often do this to help determine what changes need to be made in my own art.

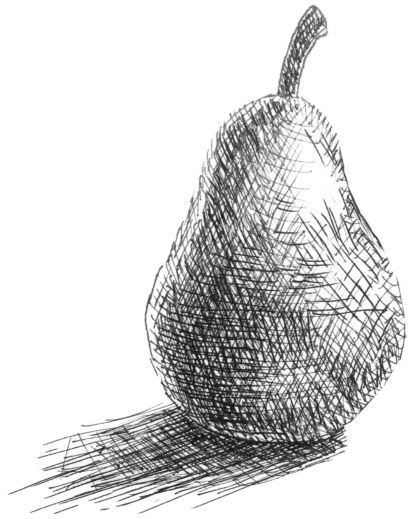

The same pear outline can be used to illustrate the use of hatching and crosshatching. This method is one of the quickest and most effective ways to create value with pen. Start by laying down some hatch and crosshatch marks to shade this in. As before, the dark areas are tackled first, followed by less dense lines to fill in lighter areas. By curving the lines around the inner contours of the pear, I can make the shading appear more realistic, similar to creating cross-contour lines but closer together to indicate shade as well as form. Following the shape of the pear helps to make it look three-dimensional. Only hatch marks are used to start; however, eventually crosshatch marks will be added so that some areas appear even darker. For now, laying down some lines will help to block out some of the whiteness. I will continue to do this over the entire pear until most of the areas are covered with line. Once the initial tones have been laid down, some areas can be darkened as needed, drawing some lines closer together and crossing them over one another. Even though we don't want to completely outline our pear (since

objects in real life do not have dark outlines around them), we can outline to a certain extent around the darkest area because those lines will eventually blend in with the shading that we are creating. The stem is very dark, so that area requires more crosshatching as well as the area where the pear touches the surface it sits upon. All of these tones are created with lines while following along the cross-contours of the shape so we can see all the pear's definition. The hatching stays somewhat parallel while still curving around the contours of the fruit. Always leave some white space open for the highlights, avoiding putting any line on the lightest areas. When making highlights with pencil it is easy to mark over them and erase them later. With marker or pen, we cannot erase, so definitely leave any areas of highlight blank until you are sure that there should be tone on them. The more lines you put down, the more defined the pear becomes. This includes the shadow, which is quite dark, especially where the pear touches the table. I made some tight lines in the area directly where the pear touches the surface it is sitting upon. These lines become sparse as the shadow becomes lighter. Crosshatching in the darkest areas of the shadow ensures that they are indeed dark. Also, more darkness where the pear meets the table can be added just to show that it does move inward, away from the light source. Just keep working on it until you, the artist, are happy with it.

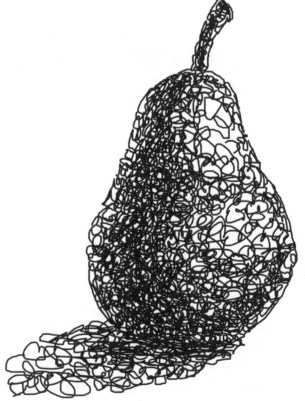

Artwork by Tamara Eden

Yet another way to shade with pen is scumbling: a fun, sketchy way to fill in an area of tone quickly. In drawing, *scumbling* is a term used to describe a random, scribbled texture created with figure eight or rounded shapes. Scumbling uses layers of these tightly drawn scribbled marks to build up value and texture. This method is one of the fastest and easiest ways to fill in an area quickly and create an interesting texture in your drawing. It is not frequently used when shading realistically.

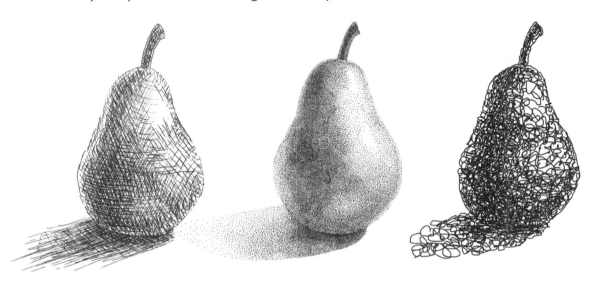

These different techniques will give you a variety of results. Try them all to see which one you prefer. The technique an artist chooses can help determine his or her personal style.

Tips:

• When shading with pen, ink, or marker, marks cannot usually be erased. This idea can be a bit daunting, so take precautions to avoid mistakes.

• A simple pencil outline drawing that can be drawn over with pen and later erased can serve as a helpful guideline.

• Start hatching, stippling, or scumbling the darkest areas of an image first, but do not make them as dark as they should be. Fill in the remainder of the shade first, then go back and darken any areas that need it. You can make an area darker, but you cannot make it lighter. Resist filling in the light areas since marking them in will lead to less contrast.

• Practice drawing your marking technique before (and perhaps even during) the creation of your art on scrap paper. This can be especially helpful when using a pen that has an irregular stroke or a tip that clogs.

• For the most realistic outcome, shade along the contours of the subject. By following the contours, an artist can offer more depth in his or her shading.

• Strokes and marks can vary in direction and density. Choose which one is right for the surface you are trying to replicate.

• Don't forget to create your shading using layers of line, stipple, or other marks. Values are built by layering marks on top of one another or close to one another.

• When a mistake is made and there is no solution in sight, some inaccuracies can be fixed with Liquid Paper. This is not the best answer since the surface of the paper is changed and the artwork may look patchy in places where this Liquid Paper is used. The pen mark may also take on a glossy sheen when marks are made with it on top of the Liquid Paper . Avoid using this "fix" if possible.

• Don't limit yourself. Try mixing your newly learned pen shading techniques with other mediums. A popular way to enhance pen work is to outline a water-color painting or add colored pencil to one area after the pen drawing is complete to create a focal point. The use of hatching, crosshatching, and scumbling can complement countless mediums.

Examples, Questions, and Comments:

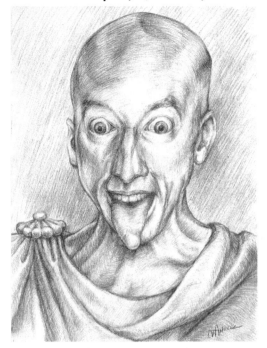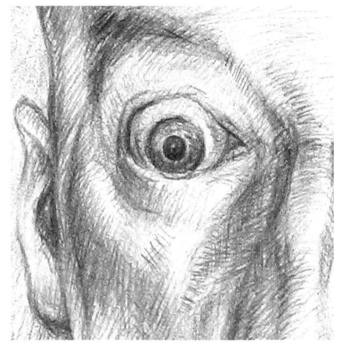

Artwork by CVHolmes

Example of crosshatch shading technique using pencil with detail (right).

Artwork by CVHolmes

Example of crosshatch shading technique using pen.

Examples, Questions, and Comments

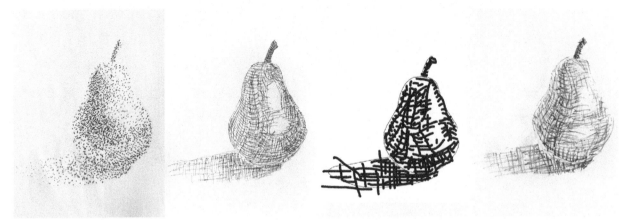

Artworks by Whitney Krug (age 12)

Question: I tried shading my pears using different techniques and types of marker. The third one was done using my computer. I love the crosshatching technique. I tried to pay attention to how far apart (and how close) I put the lines. What do you think?

Reply: I love how you explored each technique using different media. As you can see, every tool (and technique) offers something different. Whichever one you like best is the one you should focus on and refine your skills with.

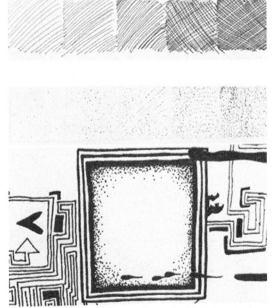

Question: I decided to break the rules and forgo the still-life art and stippled something else. I'm grateful you had a portion on ink shading. What do you think?

Reply: Good for you! Art is all about knowing the rules and also knowing when to break them. It is always fun to experiment and play with new materials and techniques, especially if you find that a lesson is taking you in another direction that originally intended. By all means, explore this. Do, however, go back at some point and try the exercises in the lesson.

Some exercises may seem arbitrary, but they offer some basic skills that you need to know in order to become a better artist. Learn the basics and follow the rules, especially when you are first starting out. This will help you to determine how and why certain techniques are used. There is originality and creativity involved when breaking the rules, but you need to know why the rules are in place. That way, you can have a reasoned decision to break from the norm.

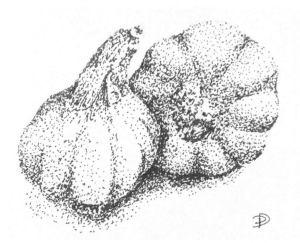 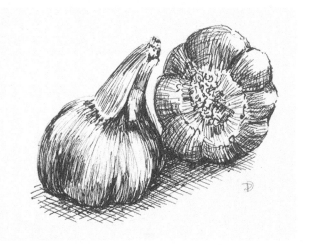

Artworks by Pamela Dowie

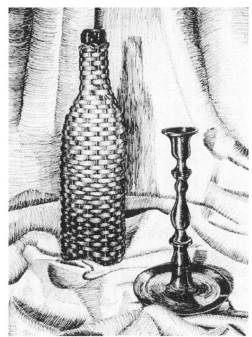

Artwork by Celena Foglia *Artwork by Emma Manlapaz*

Artwork by Jassimran Sra

Artwork by Kristia Bondoc

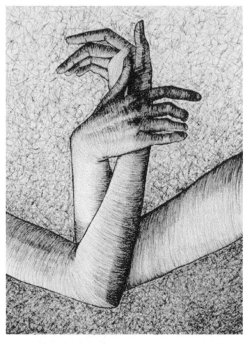

Artwork by Yee Lam Maggie Lo

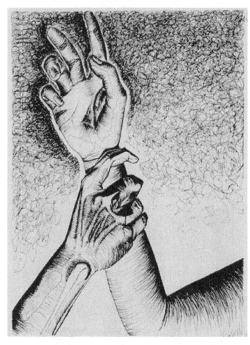

Artwork by Rubi Loya Mora

Question: I did my sketch of the pears using a 4H pencil and I couldn't erase it. I thought H pencils were supposed to be light?

Reply: Harder graphite, marked with the "H" grade is meant to leave a light line. When an artist is laying down a sketch or outline for a drawing, they often choose "H" pencils because they make a light mark that is usually easier to erase if needed. Harder leads can also be used for soft/light shading in some cases. If you press down with an "H" to try and get a dark mark, you will leave dents in the surface, and the marks will be difficult to erase. If you feel like you are using too much pressure, change to a softer grade pencil. I use HB pencils or 2B when sketching. Keep practicing and you will eventually figure out which pencils you prefer.

Question: Does a Sharpie work better than a fine pen when stippling?

Reply: A Sharpie will not work better or worse than a fine pen when stippling; it will just offer different results. A regular Sharpie will leave a wider/thicker dot mark, while a fine pen (i.e., ultra-fine point Sharpie) will leave a much smaller mark. The finer the pen, the more stipples you will need to create! This usually means the artwork will be more time consuming.

Question: Can I use stippling, hatching, and crosshatching all in the same drawing or should they be used separately?

Reply: You can absolutely use them all in the same artwork. In most cases, they will complement each other and not conflict with each other. Hatching and crosshatching, combined with stippling, can be used to suggest a variety of surface qualities. It is probably more effective to apply the crosshatching first in order to build up the tonal structure of the drawing, followed by stippling, which can add subtlety and texture to the work.

Question: How do you get your dots so uniform? I always get dashes and dots of varying sizes.

Reply: There is no trick to it, just time and patience. Rest your wrist on the table so you're more likely to get a consistent mark. Also, take breaks as needed. It's very tedious making all those dots. When I start to get sloppy and find that my dots no longer look like dots, I set the artwork aside and go back to it later. Stippling is definitely not a quick resolution for shading.

Question: "What do you do with artwork that doesn't quite work out?"

Reply: Keep it! Every attempt at an artwork is an effort that strengthens an artist's skills. You can always refer to it later to see your mistakes or measure how far you have come.

Comments:

"I definitely like hatching and crosshatching better than stippling. Stippling has too many rules and is so time consuming. With crosshatching, I can make looser movements and express myself."

"I prefer stippling because sometimes my lines don't come out very curvy when I am trying to shade in rounded objects. Plus, I find dots easier, even though they can take up a lot of time."

"I enjoyed using the hatching style more, as it was easier to draw the shapes with. I will save the stippled technique for special drawings."

Comment: I didn't really grasp the crosshatching technique, but I wasn't aware of stippling for shading. Scumbling was a lot of fun to try and helped me to loosen up. I was able to fill in a large area quickly without being precise."

Reply: Practice what you don't understand. If you don't like it, don't do it! There are many techniques to choose from, and there is something out there for everyone.

Artworks by Peter Lutes

"Ms. Holmes's crosshatching and stippling exercises showed me how use marks and layers to indicate intensity, shade, and direction. I've been fond of drawing curves since the second grade when I fell in love with art. This lesson renewed my appreciation for art and reminded me that there are many opportunities for choices an artist can make when tackling a project. Here, I have tried my hand at using pen and pencil to see which technique I liked best. I like them both!"

CHAPTER TEN
CONTRAST AND FOCAL POINT

Know:
• Contrast is the arrangement of opposite elements in an artwork.
• Elements that standout from one another can be used to create a specific area of interest in a drawing.
• A focal point is the element in a drawing that is the center of attention or the main subject.

Understand:
• Any image can be enhanced by the use of contrast.
• An artist can use contrast to depict a mood or make an artwork visually pleasing.
• It takes practice, knowledge of natural shading techniques, and keen observation to determine where to intensify tones and add highlights realistically.
• Drawing from imagination requires experience and knowledge of drawing from observation in order to be believable.

Do:
• Explore stylistic effects by adding contrast to different areas of an image to show emphasis.
• Explore the variety of areas in a drawing that can have a focal point.
• Practice using contrast and focal point techniques by placing deep shade next to bright highlights or extreme detail to a specific area in a drawing.

In this lesson, we will discuss creating contrast within a work, establishing a focal point using contrast, and we will analyze high-contrast versus low-contrast images.

Contrast

Contrast is simply defined as a difference between two or more things. Contrast in art stresses the difference between two related elements such as color, shape, value, type, texture, alignment, direction, or movement, helping these elements to stand out from one another. This lesson will focus on the differences between light and dark. One of the most powerful ways to show contrast is to make a difference in the tones created in an artwork. Darker values can indicate shadows, deeper tone, or darker value. When these dark tones are placed next to areas of highlight or lighter tone, contrast is created.

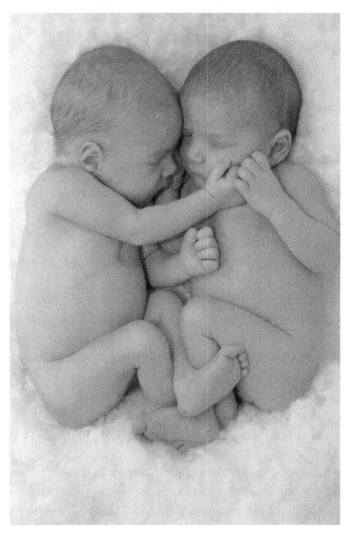

Almost anything can be enhanced by the use of contrast. Here's one of my favorite photos of my twin daughters after they were just born. The color version shows a brilliant white background with soft peachy flesh tones, cre-

ating a gentle flow of one color into another. When I transferred this photo from color to black-and-white, however, the image lacked any contrast and was not as interesting. The tone of the skin does not stand out against the lightness of the background as both tones converted into tones of light gray. In order to build a pencil drawing of this image that is more vibrant, I will need to take some liberties and add contrast in some form or another. This can be done in several ways.

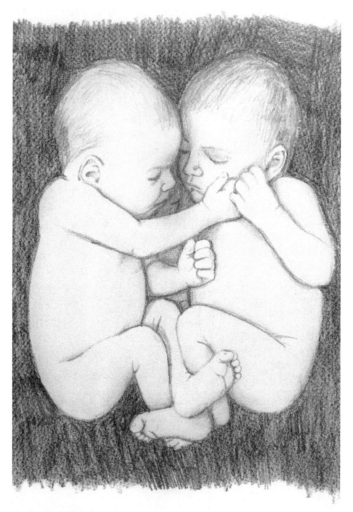

In this first example, I have created a drawing of the girls that is similar to the photo. The major difference between the photo and the artwork is the addition of more contrast. The background has been filled in completely in order for the babies to stand out more. Changing one of the elements in an artwork from light to dark can offer interesting results. In this case, the dark background makes the babies stand out, as the lightness of the skin appears brilliant against the darkness of the surface they are lying on. The

babies are the obvious focal point. This is one technique that can be used to create contrast in any work: darken one area while leaving another light. Sometimes when this is done, the lighter portion of the art will look washed out. To solve this, bring some of those deeper tones into the light area, darkening the shadows and further reinforcing the contrast without sacrificing too much realism.

Use whatever resources and images that are available to you to practice with. Image searches can offer some great reference photos to use while family and friends can be posed to fit your needs (and are royalty free)!

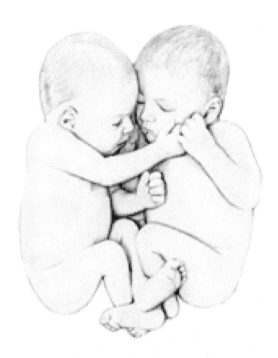

The opposite approach is to make the details on the main subject darker and leave the background light. Another photo of my girls above shows deep shadows and prominent highlights. Since the background is so light, the babies appear to float in space, as there is no indication of a surface they are lying on. This can be a stylistic effect an artist may want to explore. A subtle shadow can be added under babies to indicate a surface for a more realistic approach. Whenever a part of an artwork is re-created and changed from how it appears in real life, the artist runs the risk of making the artwork ap-

pear unrealistic. It takes practice, knowledge of natural shading techniques, and keen observation to determine where to intensify tones and add highlights realistically. Which one do you prefer? Everyone has different tastes and opinions as to what is appealing or not in art. There are many choices to approach a drawing and the images above are only two. The beautiful thing about art is that you have personal preference and choice regarding what areas to emphasis and what medium to use.

Here is another photo of my girls, taken by fellow artist and friend Rhiannon Peduzzi Prunes. In color, this image is visually vibrant and warm; however, it lacks some energy when converted into in black-and-white: the warm, pinky skin tones that formerly glowed next to the brightly colored headbands are not as compelling in tones of gray. To make the artwork visually pleasing and more interesting when drawn on paper, contrast can be added.

One tool that can be used to quickly block in large areas with darkness quickly is charcoal. Charcoal is a burnt organic material and comes in many forms, usually wood (including grape vine) that has a unique look and texture when applied to paper. There are various types and uses of charcoal as an art medium, but the commonly used types are: compressed, vine, and pencil. I have chosen to use vine charcoal, which applies to the paper with little pressure and is easy to erase when light marks are made. Vine makes a lighter mark than compressed charcoal and blends easily. Drawing with charcoal is different than drawing with a pencil and will achieve different results. Vine

charcoal and compressed sticks that are not enclosed in wood-like pencils may take some getting used to when working with them. Usually, the marks made with charcoal are darker than those made with pencil.

Since vine charcoal comes in stick form, it can be difficult to add fine details to a drawing, forcing the user to simplify elements of the work. This tool may be beneficial for artists who are first starting out drawing portraits or practicing creating a likeness. Capturing the likeness of a person can be one of the most challenging parts of drawing a portrait. Even skilled artists can struggle with replicating the features of a person they're trying to depict, obsessing over specific details such as the shape of the lips or a wrinkle in the forehead while losing the character of the face as a whole. The secret to getting a good likeness is to be less specific. Charcoal allows an artist to create a hint of a person's features while focusing more on the light and dark areas in a subject (the highlights and the shadows).

It is especially difficult to draw a likeness of someone you know. If you've ever tried to draw a loved one, you know that a drawing doesn't really capture the essence or personality of that person. A person's funny expressions or serious demeanor can be difficult to replicate when putting pencil to paper. An artist can be tempted to draw what they think they see as opposed to what is really there. I find drawing people whom I love very difficult because a drawing cannot capture all that they mean to me. An excellent way to avoid this predicament is to focus on value rather than line at first. Darks and lights can reveal so much more than simple outlines. In this case, interpreting the work without extreme detail solves a lot of those issues.

Above is a quick sketch focusing on value, rather than line. For this artwork, I started off by quickly filling in the darkest areas first followed by the major details of each face, leaving the background white to see if I liked how the artwork was developing. I squinted my eyes to visually simplify the complexity of the subject. The act of squinting enabled me to block out minor details and focus on the simple values and shapes, enabling me to draw my subject more accurately. The result is decent representation of the image I was trying to re-create. I added more contrast than the original image depicted in order to make certain areas stand out, darkening some of the shadows and lightening some areas of highlight. The facial features and flowery headbands stand out; however, the artwork as a whole is not as vivid as it could be. If the background is changed to a dark tone, the flesh tones of the skin next to it will appear lighter and will stand out more, creating even more contrast and more of a focal point.

Filling in the background with the charcoal using a quick back-and-forth motion creates an interesting opposition of tones that can be much more successful than leaving the background white. It took less than a minute to block out the background and that simple change makes a huge difference in the composition overall.

A lot of dust is created when shading with charcoal. Charcoal is a dusty medium that can be easily smudged or smeared, so great care should be taken when creating, transporting, and storing a work in progress. While working, make sure your hand is not resting on areas of shade, as it will smear your work (as well as get all over your hand). Try not to blow any loose dust into the air but rather shake the dust off onto the floor or the trash can, that way, charcoal particles are less likely to be floating in the air and inhaled. The people around you will appreciate it!

When an artwork is complete, it is common practice to "fix" the charcoal in place. In drawing, a fixative is a liquid, similar to varnish, which is sprayed over a finished piece of artwork to preserve it and prevent smudging.

There is workable fixative that allows an artist to fix layers of a work in progress so that they may continue adding more layers without disturbing the layers under it. There is also final fixative that is used when the drawing is finished and no other changes or additions will be made to it.

Fixative is most commonly available in aerosol sprays and is applied by holding the can at least one foot away from the work when spraying the surface. Most fixatives are considered to be chemicals and should only be used in a well-ventilated area, preferably outdoors. In a pinch, hairspray can be used in place of fixative, but it can darken the surface so it is not recommended.

Focal Point

The focal point of a drawing determines where the viewer's eye will travel. Any area that stands out more than the rest is what will attract a viewer's attention first. This is called the focal point. A focal point acts like a visual magnetic, pulling the viewer's eye to a specific area of a work of art or design. It may or may not be the center of a painting or drawing, but it is always one of the most important parts of a work, a part that stands out the most. When an artist creates a focal point, they are emphasizing a particular part of a drawing that they want the viewer to notice. The area that is chosen can vary and depends on what the artist wants to highlight.

There are many ways to create a focal point in an artwork. The most popular way is through the use of contrast. Contrast can be created by applying variations of color, value, texture, shape, or form. By emphasizing one or more of these elements, an artist can increase the contrast and strengthen the focal point. Another way to create a focal point in artwork is by separating an object or element from the rest of the image. This is called isolation. The placement of objects within a work will also determine the focal point. Objects that are placed in the center or near center of a work will naturally become a focal point. Most of the time, a focal point that is not exactly center is preferred. Implied lines, such as the direction or placement of secondary objects can direct a viewer's eye to an object or element. This technique is known as convergence. Another way to create a focal point in artwork is to introduce an object or element that is unexpected. This unique addition will stand out and demand attention, thus creating a focal point. Any part of a picture that exhibits these features will make the viewer focus his gaze upon it.

Let's practice creating a focal point using contrasting tones.

Here is an outline of a lady wearing a large, floppy hat and sunglasses. There is not much detail in this drawing and no shading as of yet: it is basically a blank canvas for an artist to shade in whatever way he or she chooses. In order to create a focal point, we must first decide what area of the artwork we want to have stand out. This involves making a portion of the image stand out by adding detail or contrast to one or two areas. This can be done in several different ways, depending on what I want the viewer to focus on. If I want to draw attention to her lips, I could shade them with extreme detail by adding contoured lines for skin folds, highlights, and intense shadow. I could instead concentrate on creating an intricate woven pattern on the hat or draw a detailed flower on the brim, leaving the remainder of the artwork a lighter tone or not as detailed. In this example, I would like to bring attention to the sunglasses by adding deeper shading and reflections to that

area. This doesn't mean that I will leave the rest of the line art untouched. The whole artwork should have some degree of shading; there will just be more in one particular area. Draw a simple outline as seen above by following the steps provided; trace or create your own line art to use for this lesson. Line art or line drawing is any image that consists of distinct straight or curved lines placed against a (usually plain) background, without gradations in shade (darkness) or hue (color) to represent two-dimensional or three-dimensional objects. Notice that the outlines of this example are somewhat dark. This is only so you, the viewer, can easily see the line art. Usually, it is good practice to draw lightly. Drawing with a light touch and controlling the pressure of the pencil line is a vital part of drawing. While I am drawing, I often press so lightly that my pencil tip barely touches the paper, leaving a line that is barely visible. I use the light marks as a guide to where other marks will be placed. If I find that a line needs to be changed or moved it can easily be changed. As the drawing becomes more complete, I will gradually increase the pressure of my marks during the shading process. Even though the sample outline of the lady appears dark, make your drawing very light.

Sun Hat Lady

1. Start with an oval head connected to a lean neck and gently sloping shoulders. Add a 1/2 circle slightly above the head area as shown.

2. Create the hat by adding a curvy sliver shape below the 1/2 circle drawn in step 1. Erase areas indicated by dash lines.

3. Add two circle-like shapes connected in the center as shown. These will be the sunglasses. A portion of the sunglasses will be covered by the floppy hat.

4. Add a few light lines to indicate the nose and lips. Notice that the lower lip is not connected to the upper lip.

5. Draw the hair. Notice the the left side of the hair falls behind the shoulder and the right side of the hair falls in front of the shoulder.

6. Add the remainder of the floppy hat. This illustration shows the "underside" of the hat.

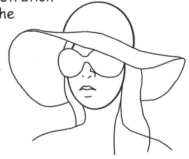

154

Once you have a light outline of an image to work with and you have decided what area is going to be the focal point, the shading can begin. The artwork above has a single, light layer of shade on the areas that will be the darkest. At the moment, one area does not drastically stand out more than another. Putting an equal layer of shade all over an image before focusing on one area helps to make an artwork look complete, regardless of the amount of work needed to be done to it. A soft, blended layer of tone also creates some contrast against the lightness of the background, making the depth of the figure easier to see during the beginning stages.

The next layer of shade will bring a bit more detail. Notice there is a light shadow where the hair meets the hat and under the chin. A subtle pattern consisting of light and dark lines has begun under the brim of the hat near the hair and on the right side of the upper portion of the hat. This primary lay down of value is basically even in tone and does not show extreme contrast. If I were to stop shading and leave the drawing as it is now, there are a few areas that would stand out. The shadow under the chin is showing depth as it appears to jut out over the neck, and the subtle patterning on the hat creates interest and attracts the viewer's eye; however, I want to continue to add more detail and take this drawing to the next level by adding even more contrast and depth.

The upper lip and more of the hat has a light layer of tone added in the example above. In most lighting situations, the upper lip appears slightly darker than the lower; therefore, I will not add too much detail or tone to the lower lip. To add more contrast, I have darkened the sunglasses, which helps them to stand out against the lightness of the rest of the drawing. Still keeping the initial lay down of tone light, I have blocked the lenses with a quick back-and-forth motion. As you can see in the artwork above, the glasses are already starting to become the focal point of this artwork.

A slight curve of shadow has been added to the lower lip while more detail has been added to the sunglasses. The lenses of the sunglasses have some very simple geometric shapes blocked out on them to represent a cityscape reflection, indicating the impression of what the woman wearing the sunglasses is seeing. These shapes were created by lightening the areas around them with the kneaded eraser. These squares and rectangles vary in size and have been rounded at the corners to follow the slight curve of the lens. It important to have some short shapes and some tall since they may not appear as interesting if they were all the same size. These are not drawn perfectly or very detailed, as they are simply indicators of a reflection. Since the hat extends over the sunglasses, the shading is deepened near the upper portion of the glasses and the forehead area so they appear to be in shadow. There is also a light shadow falling on the face cast from the sunglasses. More shading under the hat will help to define these parts as well.

Adding darkness to a specific area while maintaining depth can be tricky. More shading needs to be added to reinforce the idea that this is a three-dimensional image. Simple curves can be darkened on the inside of the rim of the sunglasses as well as shadows near the bridge of the nose. Some of these marks are subtle and others are much darker, depending on the light source.

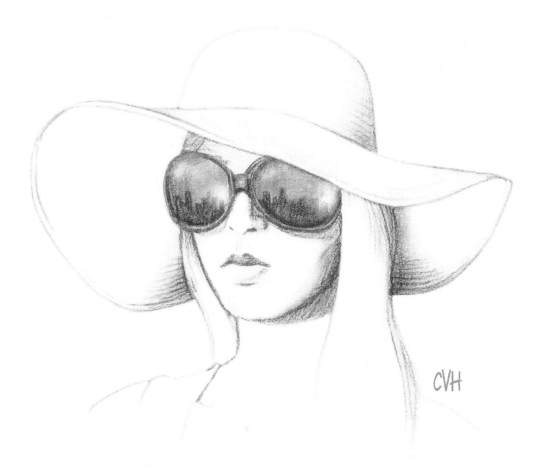

The final artwork offers more tone added to the face to define the cheekbones, a shadow cast from the sunglasses onto the face, and more patterning on the hat and clothing detail. To define the reflection and make a highlight, I have used the kneaded eraser and lightened some of the pigment in the lens. Whatever I did to one lens, I did to the same thing to the other to be consistent. When working from life, the reflections may appear in different areas. Deepening the darker areas of the sunglasses while keeping everything else around it lighter offers a quick and simple way to create contrast in this drawing. The same technique can be used for any drawing to create

a focal point. If there is a certain area that an artist wants to draw attention to or have the viewer focus upon, creating a focal point using contrast is a popular technique.

The viewer's eye is naturally drawn to areas where light and dark are in stark juxtaposition. Creating a focal point using contrast can be a powerful way to build interest and movement within an artwork. Areas that support the focal point visually become secondary in importance. An artist can create more than one focal point in a design, and those points can either compete with or complement one another; it all depends on what the artist is trying to communicate.

Contrast is another component that adds dimension and makes a work more engaging. An artwork does not need to have a complete range of tones to be an effective image. The use of deep darks and vivid highlights, without many midtones, can keep an image from appearing flat. Examples of contrast can be seen by observing the world around us. As lighting conditions change or as the sun changes positions in the sky, the way a scene is portrayed is affected.

This above photo is an example of an image with high contrast. I took this photo early in the afternoon on a bright day when the sun was high in the sky, around noon. Although the sun is not in the photo, the viewer can see where its approximate location of the sun is because of the shadows. The lamppost seen on the left of the photo is casting a long, dark shadow that stretches all the way toward the right. This darkness against the lighter tones of the grass create high contrast. Objects in the background also indicate high contrast: the trees, shrubs, and building structures are clearly darker on their right sides (the side of each object that faces away from the light source), while the sides of each object facing the sun appear lighter. These shadows create intense contrast in the photo as compared to the same scene viewed at dawn or an overcast day.

This is an example of a low-contrast photo. It was taken early in the morning on the same day as the high-contrast photo; however, the tones make the image appear very different. Even though the angle in which the photo was taken is similar, the sun's position in the sky is not the same, therefore,

changing the dynamic of the photo. In this low-contrast photo, the values are more muted. The sky is light and the objects in the foreground and background consist of medium tones. There are not many intense darks or bright highlights to be seen. The long shadow cast from the lamp in the high-contrast photo is gone, and the distinct dark and light areas of the structures in the background have been muted.

These two photos are great examples of how a light source and contrast can change the way an image appears. As an artist begins to understand how contrast can change through lighting conditions, they can manipulate contrast in an artwork to benefit their style or what they are trying to convey. The degree of contrast that an artist uses depends on the desired effect and can make a huge impact on the final product.

High-contrast artwork shows a distinct difference between dark tones and light tones using minimal medium tones of gray. Low-contrast artwork depicts many shades of similar gray tones but lacks many deep darks and light highlights. Simply put, high contrast has dark tones that are very dark and light areas that appear very bright. Typically, something that is low contrast will appear to have a gray wash to it, muting the deep darks and the bright lights into tones of gray. Either way can be successful, depending on what the artist wants to communicate.

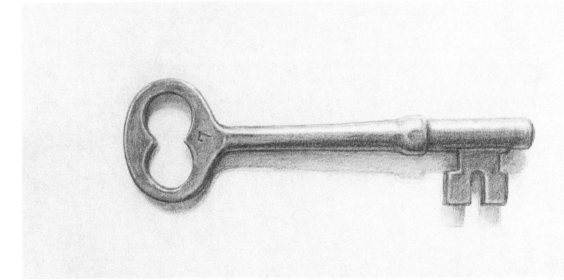

Another example of high contrast can be seen in this drawing of a key. There are some intense highlights to indicate shiny spots on the key as well as very light tones on the areas of the key closest to the light source. In contrast, the areas farther from the light source are very dark while a dark shadow is cast. There is a little sliver of reflected light shown on the dark side; however, the

dark shadow extends all along the edge and remains intensely dark against the lighter areas. To create high-contrast shading, press hard with your pencil or use the 6B to 9B drawing pencils. The kneaded eraser should also be used frequently to create highlights.

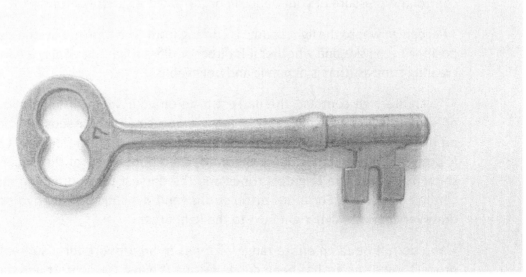

Here is an example of the exact same key using a different approach to the shading that shows low contrast. Highlights and shadows are represented; however, the tones are not intense and there is not a huge difference in the values represented (as compared to the key showing higher contrast). The darker darks and lighter lights have been blended into one another, creating subtle medium tones that lack extreme variation between one another. For low-contrast shading, use a combination of blending tones into one another to create muted grays, using light pressure with the pencil and utilizing the 2B to 4B art pencils.

Low-contrast images can be described as subtle, flat, or soft while high-contrast images can seem powerful, striking, or bold. Images showing average contrast will have some darks, some lights, and a broad range of grays represented. An artist can choose a method of creating contrast to convey a certain mood. Low-contrast works can appear stark, bland, solemn, or mysterious while high-contrast works can also appear to be sharp, sinister, or dramatic depending on the subject matter. The approach used by an artist should be based on what mood they want the final artwork to encompass.

Tips:

• To create appropriate contrast in an artwork, it is crucial to learn how to control the pressure of your pencil in order to get a variety of tone.

• Recognize where the light source is coming from. The time of day, the sun's position in the sky, and whether it is direct or diffuse lighting all play a part in creating contrast that is dynamic and believable.

• To create high contrast, the darkest tone on your value scale should be present. That may mean that a large area or a small area needs this added darkness, but the end result will have more impact if the darkest tone is present. Equally important is the untouched pure white of the paper to show highlights. The brightest tones and the darkest tones offer the most contrast in a work. For a powerful, strong, and dynamic drawing, you can draw very dark shading right next to the light areas.

• You do not need an entire range of tones in an artwork for a successful product. Amazing art has been created using the just the lightest and darkest tones with a few midrange tones.

• Use your value scale to your advantage. Some artists make a proper value scale representing a range of tones but are often timid when it comes to re-creating the darkest tones on their actual drawings. It is good to be cautious since it is easy to make an area too dark but not so easy to make a dark area light again. Remember that to be a good artist, you must take risks and go out of your comfort zone. It is just a piece of paper, and the world will not end if you make a mistake. Just do it!

• Practice creating focal points in your artwork. Take creative control to put focus on a certain area of your work. Contrast and extra detail are popular methods used to focus attention on a particular part of an artwork first.

• Play around with your image by making certain areas darker or lighter than they should be (such as the background in the "babies" images earlier in the chapter). Change the background from light to dark or vice versa. Which do image you prefer? Experimenting in this way is a good way to explore contrast and is a quick way to change the dynamic of an artwork.

• Experiment with low-and-high contrast techniques using the same subject matter. Some subjects need to be presented as soft and gentle and are best suited to low-contrast techniques. Other subjects need to be represented as dramatic and impactful and are best suited to high-contrast shading.

• Seeing value is crucial to creating contrast within a work. Squint your eyes to simplify your subject matter and block out minor details while focusing in on the major values and shapes. When you can see the shapes created by different values, you can draw your subject more accurately.

• When drawing a likeness of someone you know, draw what you see, not what you think you see. It is easy to get caught up in changing an image to fit what we perceive it to be. This often changes a work in such a way that it no longer represents the image we are trying to capture.

Examples, Questions, and Comments

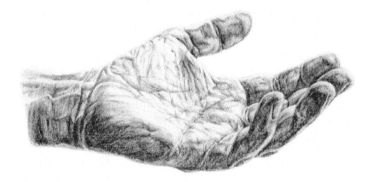

High contrast artwork by CVHolmes

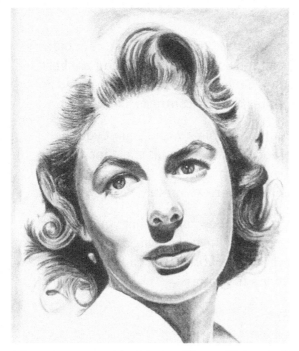 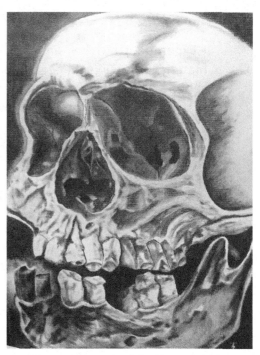

High contrast artwork by Johanne Climaco@johanneclimaco *High contrast artwork by Sixto Martinez*

Question: If I want to use the charcoal to get dark blacks, is it okay to mix it with normal pencil?

Reply: It is definitely okay; however, the charcoal is going to make a much darker and intense mark than your pencil will. The combination of charcoal and pencil within a work might not offer the continuity you are looking for; the charcoal might be overwhelming against the finer marks of a pencil. Test an area before committing to it and see if it is the look you are going for.

Question: The nose is hard for me to draw; my lady's nose looks like a prosthetic nose!

Reply: When in doubt, just draw a hint of the nose and rely on the shading to create subtle highlights and shadows to form the shape. It is easy to add outlines around the whole thing as opposed to creating a variety of tone only where it is seen. Less is more!

Question: Here is my low-contrast drawing. I didn't intend for it to be low contrast originally, but it naturally became that way as the drawing progressed, as I was trying to keep the focal point on the smile. Have I succeeded in showing the right expression?

Reply: Yes, this is a beautiful example of a low-contrast portrait. Sometimes, especially when drawing portraits, high-contrast shading can appear too harsh. This image offers a soothing, gentle approach that complements the gentleman in the artwork. Another good reason to choose low-contrast shading in a work is to create a soft, complementary resemblance. Older folks tend to have more lines in their face, and high-contrast shading can offer a less-than-flattering likeness.

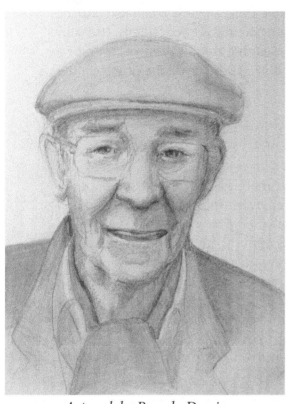

Artwork by Pamela Dowie

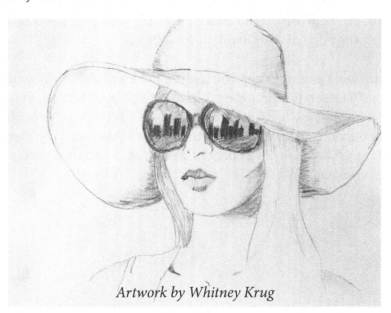

Artwork by Whitney Krug

Question: I'm trying to draw a family member for the focal point assignment, but it doesn't look like the picture I am working from. The placement of the hands isn't quite right, and it is a little tilted. Do I need to redraw it?

Reply: You don't have to redraw the whole thing since you can take artistic license and change positioning to a certain extent to fit your needs. Use your kneaded eraser to change the major areas that need to reflect more of a likeness to the person you are trying to draw. These areas are usually in the face, especially the eyes.

Question: If I wanted to do a drawing in charcoal, what would I do to make it less dusty and to keep it from rubbing off?

Reply: That's a great question, but unfortunately I don't have a perfect solution for you. I used to place plain paper over areas I had completed so I wouldn't accidentally smear them. This helped a bit, but it could get annoying to keep moving the paper every few minutes to see the progression of my work. A better suggestion is to work vertically on an easel as opposed to horizontally on a table. This allows your charcoal dust to fall out of the way, and it prevents smudging from your hands. Also, you don't need a large amount of pigment in order to get the effect you are looking for. Less is more! To avoid smudging, the best bet is to use a workable fixative. You can spray this on your work in progress, and the smudge/mess factor goes down considerably. Hope that helps!

Question: I like using the soft (B) pencils, but I find I'm always smudging my paper with my hand. Do you do all your drawing with your hand in the air, or do you rest the edge of your hand on something?

Reply: Smudging and smearing your work can be a problem when using softer pencils. To lessen the smudging, I have often placed a piece of paper between the edge of my hand and the drawing. I have seen some artists tape a piece of paper to the underside of their hand! Make sure the paper is not soft like a tissue because softer papers tend to act as a blending tool and can rub tones into one another.

Comments:

"I definitely prefer the looks of the high-contrast artworks. I like to ramp it up a bit in my photography too."

"I like that I can decide to portray a mood in my artwork just by using high or low contrast. The viewer will feel a certain way just by seeing the type of shading I choose to use."

"I enjoy creating and looking at high-contrast art better than low because high contrast gives the drawing more depth."

"I really like the high-contrast drawings. They immediately stand out with bright highlights and clear shadows. I find that the diffused lighting in low-contrast drawings can make an object appear smoother and flawless but flat and boring."

"Low-contrast drawings work well for me because I like the soft look they leave. I like to draw dream-like, almost surreal, portraits and this method complements my subject matter."

"I prefer high-contrast drawings. The stark white against the deep dark tones create movement and visual interest. There are times when I prefer low-contrast, however. The range of low-contrast usage is so versatile. It can be used to show a grim, dimly lit day to a lighthearted subtle portrait."

Instructor comment: "Color choices (as well as value choices) will definitely affect the mood of an artwork. Using tones on either end of a value scale will usually help to create a higher contrast, while sticking with tones in the middle of a value scale will help to produce a lower-contrast work. Same with colors: bright, vibrant color will give a happier mood!"

CHAPTER ELEVEN
COMBINING TECHNIQUES

Know:
• Sketching, planning, combining, foreground, background, overlapping, gradation, value, and focal point.

Understand:
• The stages of an artwork from planning to completion.
• The techniques artists' use to capture a viewer's eye.

Do:
Using learned techniques, create a forest scene (or object of your choice) that portrays a foreground and background, uses overlapping to suggest depth, and uses a variety of shading techniques to indicate value as well as a focal point.

Combining a variety of art techniques can create interest, movement, and realism. For this lesson, we will bring many techniques together into one drawing. We will create a scene including a forest of leafless birch trees that portrays a foreground, midground, and background, use overlapping to suggest depth, and different types of gradations and value, as well as a focal point.

Here is the beginning of a sketch showing a few simple lines that will serve as guidelines for six trees. When drawing this type of scene, do not use a ruler. Straight lines will make an organic object such as a tree look stiff and unrealistic, while a few bumps and inconsistencies make the outline of the trees look more authentic. Notice that the trees are placed at different heights on the paper and they are different widths. The wider tree that is drawn closest to the bottom of the page will be the tree I want the viewer to focus on. The width of the tree and its placement on the page indicate that it is closest to the viewer. This use of perspective is enforcing the idea of a foreground. The other trees have been drawn a little higher on the page and appear to be slightly leaner. That is one way to indicate that these trees are farther in the background. The placement of some trees in the foreground and others in the background will help to indicate depth. Birch trees are somewhat simple to draw because they are long, lean, and can be simplified with a minimal branches. To reinforce the vertical lines while keeping the artwork uncomplicated, I will not be depicting the tops of the trees, placing focus on the bottom and center portion.

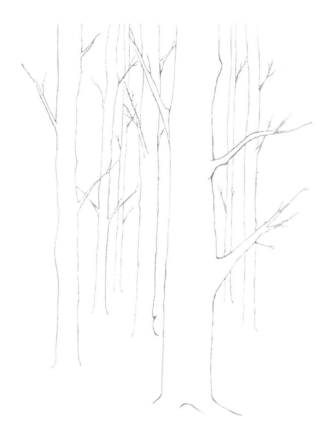

Next, add a few branches. Most tree branches will grow in the direction of the life-giving light source. The growth direction is also affected by gravity and wind. Trees will generally attempt to grow toward the light and away from gravitational pull. But, as a tree gets older, its branches tend to grow more outward than upward. That's so the tree can cast a wider net to catch the light of the sun. Make note of the direction in which your tree branches will be drawn.

When adding branches to the trunk of tree in a scene where there are several trees, an artist needs to make sure that these branches are overlapping in a way that makes sense. Branches on the trees that are supposed to be in the foreground of the scene should overlap and appear to be in front of those that are in the background. This can get tricky when drawing several trees, so be sure to pay attention to which trees are supposed to be in the front and which ones should be behind. If a branch is in front of another, draw it over the background tree and erase any areas that this branch goes through. The same thing for trees that go behind the trunks: stop drawing the branch if there is something in front of it. Trees are not transparent and should not be depicted as see-through.

Draw a ^bare Tree

On many trees, the branches grow up towards the sun ↑

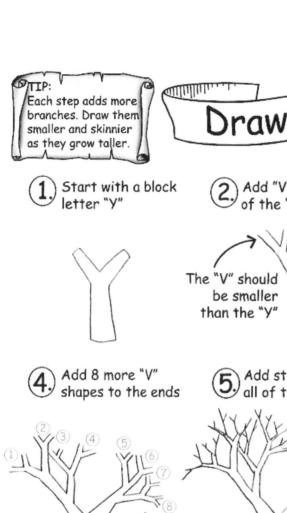

1. Start with a block letter "Y"

2. Add "V" letters to tops of the "Y"

The "V" should be smaller than the "Y"

leave the tops open

3. Add 4 more "V" shapes

4. Add 8 more "V" shapes to the ends

skinnier and smaller

branches grow up and out

5. Add stick letter "Y"'s to all of the "V" shapes

UNEVEN is good! Draw some long and some short

like this

6. Add another "Y" in the middle

(this fills up space)

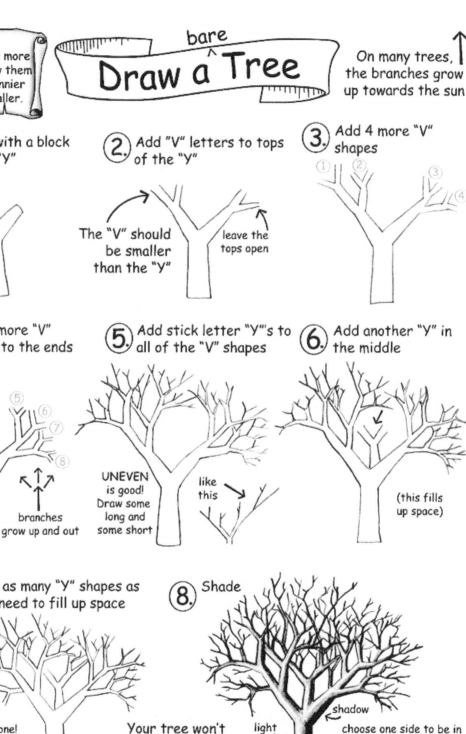

7. Add as many "Y" shapes as you need to fill up space

another one!

Your tree won't look exactly like this but that's good! Every tree is unique.

8. Shade

light

shadow

choose one side to be in the shade, then darken every branch on that side, keeping the other side light

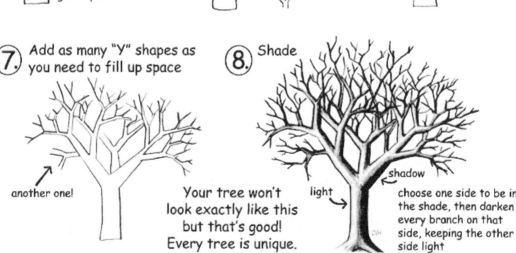

174

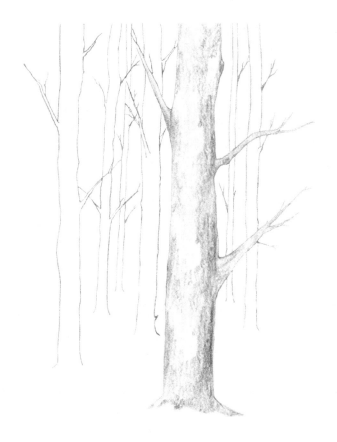

Once the basic outlines have been placed, the initial lay down of shading can begin. Decide where the light source is and shade accordingly. This drawing will indicate that the light source is coming from the left-hand side, so I have darkened the right-hand side of the tree using a back-and-forth motion with medium pencil pressure. As I moved toward the light source, I used less pencil pressure so the tone gradually appears lighter. Knowing that I can always make my artwork darker, I did not use the full intensity of tone. For the first pass, a coat of medium to light tones from right to left respectively sufficed to separate the tree from the background. The contrast will become more evident later with the second lay down of tone. This includes shading the branches as well, noting that the upper areas of each branch remain light while everything on the lower right-hand side is slightly darker.

The underside of the branches, regardless of where they are located, should be darker since the light source is coming from above. Notice the sliver of lighter tone on the side in shadow that represents reflected light. This is a small area to consider; however, the addition of reflected light helps to make the tree look tubular and rounded. A round object will have light wrapping around it, giving the appearance of some lightness on the darker side. If the tones appear too separate from one another, they can be blended to form

a smoother, seamless appearance. If the tone is too flat, add more shadow to the right-hand side or remove some tone from the left so the tree stands out from the background. It is not uncommon for an artist to go back and refine certain areas several times. Know that this is part of the process and is crucial to realistic shading; it is only the first stage starting with an initial lay down of tone that will change as the shading progresses. Blocking in these tones can also help to separate objects from the background and helps make them easier to see.

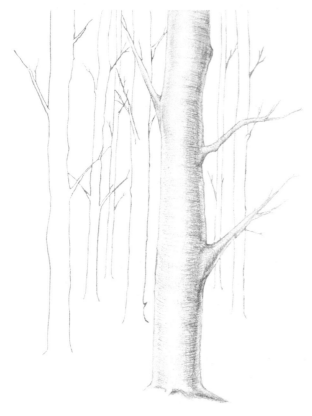

Continue to shade until there is a definite light side and dark side of the tree. Once the initial lay down is complete, tones can be blended for a more seamless look. To reiterate the fact that I want this tree to appear three-dimensional and cylindrical, I have made some light cross-contour lines that travel across and curve around the form to show the terrain of the tree. This can be done in a back-and-forth motion or swift marks made from left to right or right to left—whatever is most comfortable to the artist. The pressure should be slightly darker near the areas in shadow and lighter near the light source. This addition of shade helps a lot when shaping the tree. A multitude of lines following the direction in the form of an object when shading allows for much more depth and realism.

The trees that are in the background will have cross-contour shading depicted slightly lighter than trees in the foreground. Notice the curves of the cross-contours change direction as they move up the tree. The base of the tree has curves dipping downward, the center shows lines that are almost straight across from left to right, while the upper portion of the tree shows lines curving upward. The direction of these curves indicates that the viewer's eye line is somewhere in the middle area of the tree. The curves reinforce the fact that it is a three-dimensional cylinder as opposed to a flat, two-dimensional tree. Also, be aware that as the shading intensifies, the original outline of the tree should become blended into the shading. A crisp

outline around an object is not a realistic approach to shading. This is why it is crucial to sketch lightly. Again, it is easier to make lines darker but not so easy to make a dark mark lighter. The original outline will blend into the background even further once the background is blocked in.

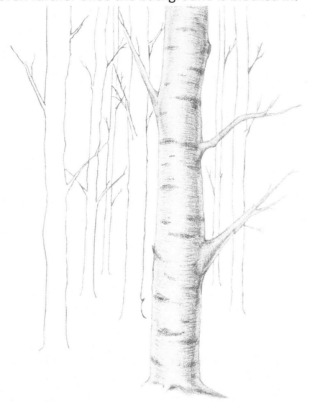

Try combining techniques to explore the multitude of ways that a subject can be depicted. Since a birch tree is a species that generally has a white or light bark, it is important to keep viewer believing the tree is light. This will allow for more contrast with brighter highlights and deeper shadows. Characteristics of this species also include random dark knots on the surface. These knots can be indicated by utilizing on the hatching and crosshatching technique. Small areas of hatching and crosshatching can be added to random spots on the bark of the tree for an authentic appearance. The knots depicted on trees in the background will be smaller to indicate that they are farther in the distance. Continue to shade, blend, and add knots until you are happy with the way it looks.

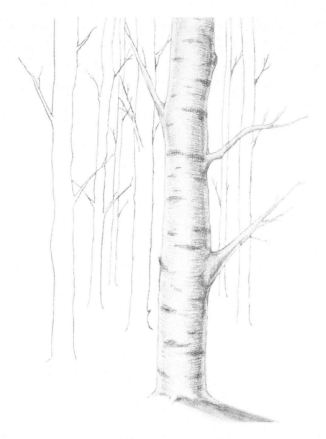

Once the shading of the tree is complete, a cast shadow should be added. Remember, since the light source is coming from the upper left, the shadow should be drawn from toward the lower right of the base of the tree. This shadow can be indicated with a quick back-and-forth motion that is slightly darker than the shadow side of the tree. Add a cast shadow for each tree, making sure that those shadows are all angled toward the same direction. When there is one light source in a scene, the shadows will all be facing the same direction. Shadows cast from the trees in the background should be lighter and thinner than trees in the foreground. These background trees should have less detail since they are not as prominent or detailed as the trees in the foreground. If the darkness on all of the trees were the same intensity, there would less of an indication of depth, nor would there be a specific tree to focus on.

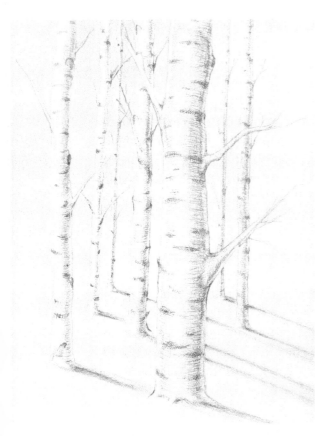

Once the trees have been shaded and a shadow has been cast, make the trees appear more realistic by adding light tone to the background. Starting near the left-hand corner of the paper, gently fill in the white background area using a back-and-forth motion with a soft pencil, such as 6B or 8B. Use a light pressure, block in all of the white with a light tone, being careful to shade right up to each tree and branch without shading on them. By filling in the background with a darker tone than the current white of the page, the white highlights and bark of the tree will appear to pop out and create more contrast. It is important to do this very lightly to begin with, as it can always be made darker later if needed. The tones placed in the background should definitely be blended into one another so those little lines of demarcation and overlaps do not stand out.

The background in this case is not something that we want to bring attention to. This layer of shade is just to enhance what we've already done in other places. Subtle tones that are well blended will highlight the other areas we want to focus on.

As I blend, I want to bring the light background tone right up to each branch, being careful not to blend over the fine branches I have drawn. I also want to bring the tone right up to and touching each trunk. A single light layer of tone works for this particular scene; however, if an artist wants to intensify the contrast, they can press harder with the pencil or go over the area again for a deeper tone. While blending, some of the background tones might accidentally smudge onto a tree or fine branch detail. If that happens, lightly dab at the pigmented area with the kneaded eraser to clean up any unwanted marks. If any lines are accidentally erased during this process, draw them back in as needed. It is a process worth doing for a successful outcome.

Once the background is complete, the white of the birch tree and any highlights added will appear much brighter and the contrast more intense. To make highlights brighter, darken the shaded areas around them. Usually, the areas of great detail or contrast is what a viewer will be attracted to first in

an artwork. In this case, the larger tree in the foreground becomes the focal point.

Notice that this artwork does not have a visible horizon line. In life, a horizon line is simply a line or indication where the land (or sea) and sky meet. In drawing, a horizon line is either a visible line or a point on an artwork where the land/sea ends and sky begins or objects recede into the distance. I did not include an actual line to indicate a separation of sky and land in this artwork, as I wanted to direct the viewer's eye from the top of the drawing to the bottom, creating a pleasing, vertical flow. If a horizontal horizon line is added to the work, it may pull the viewer's eye to a place I don't want them to focus on and disrupt the smooth flow of elements, changing the dynamic of the work. There is diagonal motion created by the placement of the branches that pull the viewer's eye inward. Some artists may decide to add a horizon line, which will create a different mood or ambiance of the final work. It would be a creative choice exercising personal preference. Whatever you choose as an artist is correct—there is no right or wrong solution to creativity and experimentation. Art is mostly personal preference and subjective. That is part of the beauty of art; there is something out there for everyone to be interested in.

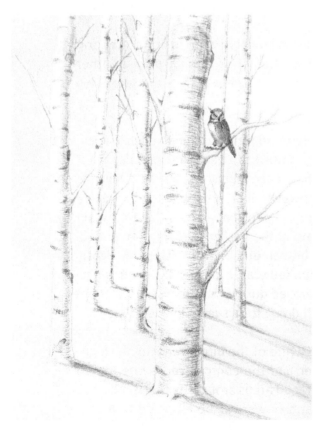

Many things can be added to an artwork in order to create more areas of interest. For this artwork, the addition of a detailed, smaller object was added to create a distinct focal point. The inclusion of the owl sitting on an upper branch draws immediate attention, forming an area of prime focus for the viewer. Notice that this addition was not placed in the exact center of the drawing. That would be too obvious and would not allow for much attraction to the rest of the artwork. Movement is key to a successful artwork if an artist wants a viewer to see every part of the effort given to creating a work. With an item placed smack dab in the middle of the paper, all of those beautiful interacting lines, branches, and shadows that were painstakingly created will not be as powerful.

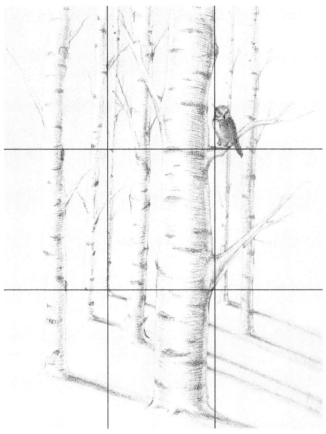

When deciding where to add a focal point, a good rule to follow is the principle of divine proportion. This is basically when an artist composes their subjects or areas of interest along imaginary lines, which divide the image into thirds, both vertically and horizontally. An artist will visually break up their artwork in progress into a grid of thirds and then pick one of those areas to place the main subject or focal point in. Following this technique helps to create interest and movement, making a work more interesting and pleasant to look at. Choosing a spot along the grid of thirds does not mean that every item needs to align perfectly on this imaginary grid. Using the rule of thirds as a rough guideline adds a sense of complexity to an artwork while keeping the main subject away from the middle of the drawing.

As you are drawing, don't forget to step back from the work from time to time and look at it from a distance. If an artist is constantly drawing and hovering over their work, they are bound to get frustrated and overthink certain aspects of it, fixating on the placement of marks or so-called imperfections that don't really matter. These imperfections are what makes your artwork beautiful and unique. Some of these mistakes should be embraced, not erased. Your unique and sometimes imperfect approach is what is going to make your artwork beautiful and engaging.

Creating art is a process, and that process is often more important than the outcome. Try different techniques and tools and be patient with your art and with yourself. Experiment, have fun, and remember that perfection is boring. Good luck and happy shading!

Examples, Questions, and Comments

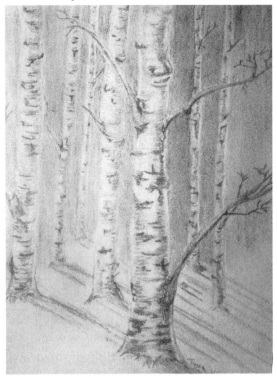

Artwork by Tyna Williams

Artwork by G.L. (age 10)

Artwork by M.M. (age 11)

Artwork by T.C. (age 10)

Artwork by Yuying Chen

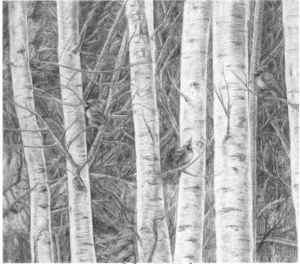

Artwork by CVHolmes

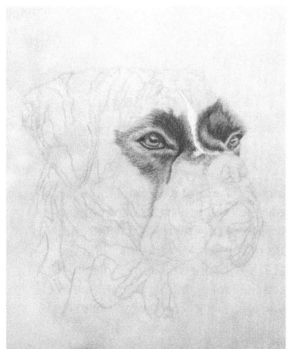

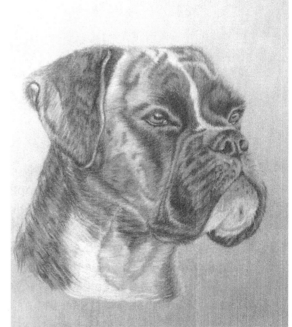

Artwork by Tyna Williams

Above is an example of one way to attempt an artwork. This student uses her skills to work on one area at a time, finishing it to completeness before moving on to the next area. Many art instructors believe the philosophy that an artwork should look at a state of completeness all the time, even if it was just started. In other words, one area is not focused on and then forgotten; the whole work is continuously being worked on. This can help with the bal-

183

ance of tone. There is no right or wrong way to do an artwork, and this student found success doing it in her own way. Whichever way works is the way to do it! In the above case, this method has worked to the artist's benefit.

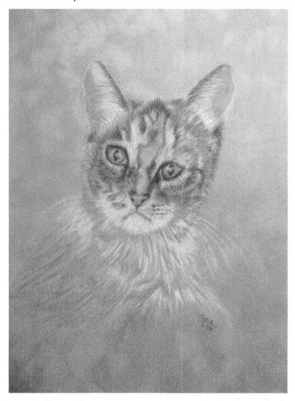

Sometimes, drawing and shading one section at a time to completion can be a detriment. The above example shows how an artist can benefit from stepping back from their work frequently to view their work as a whole, not just focusing on small pieces. The texture of this work is amazing, and the shading complements the subject matter. The eyes are well done individually; however, when viewed together, something looks a bit unnatural. One of the eyes appears to be directed toward and area slightly off center while the other eye is directed straight ahead. Stepping back from one's work before getting too detailed will help an artist to see major flaws and be able to fix them before adding extreme detail.

Artwork by Peter Lutes

"I have combined techniques to draw this birdhouse from my imagination. Building, decorating, and painting birdhouses is a family affair. My grandad used to build them, and my mom decorated them. Now I like to draw them."

Question: Can a kneaded eraser go bad? Mine is kind of oily looking, and I have been using it daily for quite some time. I also tend to roll it in my hand and play with it. Is this bad?

Reply: Kneaded erasers can dry out or appear greasy after frequent use. Eventually, your eraser may become too dirty from graphite, finger oils, or other particles that have accumulated in it. Kneaded erasers generally have a long shelf life; however, they will become dirtier with use since they absorb graphite marks. To clean it, you should stretch it and knead it like dough by rolling it in on itself. To keep it clean and from drying out, store it in a small plastic container, such as an old film canister, a sandwich baggie, or wedge it between two clean soda caps (it will stick to the caps). As long as you're still getting good results from it and it is not completely black from use, keep using it!

Question: I have all of my trees drawn and shaded in, but I think it needs more depth in the background. What else should I add?

Reply: You don't want to add too many elements to a piece after it is drawn and shaded because you will change the composition. Before you start shading is the time to draw all of your objects. Shading should be the last thing you do. To add depth, the trees in the background should be lighter and less detailed than those in the foreground.

Comments:

"I had SOOO much fun applying what I've learned in this class to my projects. I think that combining techniques has helped me to make my artwork look more interesting."

"Thank you for mentioning how contour lines change direction as they move up or down the trees. I never realized that! This is something I've been missing in my drawings, and it makes such a difference to include this small change."

"I've taken your class three times so far, and each time I feel I learn one more thing...or it finally sinks in. With your help, it inspires me to stretch and keep trying new projects!"

Reply: I am so happy to hear that. It does help to revisit a class to pick up on those smaller details you may have missed the first time around.

"I have been through and watched all lessons to get an overview and will go back and 'do' soon. Your lessons are clear, succinct, well-structured, and make so much sense. Information I have gleaned from other sources is put into focus, as do the tips and small asides. They reinforce the things I have heard before but never practiced. If I have to choose one topic that has helped me the most, it would be the highlights, blending, and shading chapter. I am very excited to bring my learned skills to my next art project."

"I was interested to hear about the rule of thirds in drawing because I understand that from photography. I never realized I could apply the same principles to my art."

"I thought my shading always had to go in the same direction. Back in my school days, I remember my teachers saying that coloring a drawing with marks going in the same direction and staying inside the lines would look the best. You have taught me that is not always true and that following the contours of an object will help my shading to look more realistic."

EPILOGUE

Creating art and learning about the variety of techniques for create realistic shading is an evolving process.

Prepare for success by choosing the best supplies for you.

Although drawing can be done with a regular pencil and printer paper, results will be more engaging and dynamic when artist pencils, paper, and erasers are used.

Create a value scale. It may seem like extra work, but creating a value scale can be a very helpful tool when creating realistic shading. A value scale will help to determine the different depths of a shaded drawing and will help an artist remain consistent throughout the shading process.

Start with a light line drawing of your subject, observing its form and contours before adding any value. Analyze the object before attempting to shade, including light lines that indicate change in planes, highlights, and shadows. Laying down this groundwork before you shade will help you to draw what you see, not what you think you see.

Locate your source of light. When adding realistic tone to a drawing, the value of light as it interacts with form, is being reproduced. The darkest tones will be placed away from the light source while the lightest areas will be those closest to the light. The direction and intensity of a light source will determine the appearance of an object.

Choose a technique (or combination of techniques) that will best illustrate your work. The subject, light source, desired texture, and artist's comfort level will determine what method of shading will be used.

Grip the pencil in such a way that is comfortable and loose. Using your whole wrist and arm to fill in an area can help to create long, smooth, sweeping lines. To add finer detail, a regular grip can offer more precision.

Lay down the initial tones using layers. Use light pressure and avoid using the full darkness of a pencil when first starting to add tone. Be sure to leave the brightest parts of a drawing untouched by tone.

Look at the object or photo you are using for reference frequently to compare it with the drawing in progress. The placement of shadows and reflections should match. If the shadows on a round edge are being replicated, abrupt transitions should be avoided. Gradual shading indicates smoother edges.

While you are observing your reference subject, notice what you are seeing and how that should translate into a shaded object. The abstract qualities of what you are seeing need to be replicated through the lines, shapes, forms, textures, and values that are on the objects.

Continue to add layers of tone to the drawing while gradually deepening the shade. The contrast between the light and dark tones will become more distinct. Change pencil grades as necessary to get soft and hard marks.

Avoid outlining an object to define it. Subtle values can transform a flat surface into an interesting form without darkening the edges. Artists can sometimes over-represent shadows within an object by making them too dark or using a line to indicate an area that doesn't warrant such a pronounced solution. Instead of defining a form using an outline, gradients of subtle tone should be used. The original outline of the drawing should eventually become less visible and blend into the shading.

Once a layer of shade has been added, tones can be blended. Marks should be even and neat, covering voids and "white spots" the surface of the paper may have embellished. Blending can smooth out tones; however, if the shaded layer was carelessly applied, blending will not enhance it.

To create soft transitions that do not have gradual appearing tones, choose a blending tool that will make the artwork appear seamless. Stumps, tortillons, cotton swabs, or fingers can be acceptable blending tools.

If highlights are accidentally darkened, use an eraser to brighten up those areas.

Step away from the artwork frequently to view it as a whole, from a distance. This perspective allows an artist to focus on the work as a whole and not just one small area of detail, as well as allowing for contemplation of the work's possibilities.

Remember that drawing is a skill that can be taught and learned, not a "talent" that one is born with. If you want to learn to draw or draw better, you can. Anyone can draw, but no one can draw just like you.

Above all else, keep drawing!

GLOSSARY

Asymmetry - Not identical on both sides of a central line; unsymmetrical; lacking symmetry.

Artist pencils - Pencils that come in various degrees of hardness, from 9H (the hardest) to 9B (the softest). The hardest pencils are used for shading the lightest areas in drawings, while the soft pencils are great for shading the darks and the middle tones. All-purpose pencils are usually graded as 2, 2HB, or HB.

Background – Parts of a scene in an artwork situated in the rear or behind the main objects.

Blend - The technique of combining tones so that there is a gentle and gradual transition from one to the other.

Blending stump - A stick of tightly rolled-up felt paper with two pointed ends. They are used to blend, smear, or smudge graphite, charcoal, or similar mediums.

Blender – A tool used to blend with.

Cast shadow - A type of shadow that is created on a form next to a surface that is turned away from the source of light. When a form blocks the light, it causes a cast shadow to be formed. Every object that blocks light has a cast shadow associated with it.

Charcoal (compressed) - a form of dry art medium made of finely ground organic materials held together by a gum or wax binder or produced without the use of binders by eliminating the oxygen inside the material during the production process.

Charcoal (vine) - Sticks are made of grape vines and willow branches that have been burnt to a specific hardness without the use of a binding agent.

Contrast – A large difference between two things; for example, hot and cold, green and red, light and shadow. Closely related to emphasis, this term refers to a way of juxtaposing elements of art to stress the differences between them. Used in this way, contrast can excite, emphasize, and direct attention to points of interest.

Core shadow - The dark band visible where light and shadow meet. It is the point at which light can no longer reach the form to illuminate it. It is the darkest area of the shadow on the sphere (the "form shadow") because it is least affected by reflected light.

Crosshatching - The drawing of two layers of hatching at right angles to create a mesh-like pattern. Crosshatching uses fine parallel lines drawn closely together to create the illusion of shade or texture in a drawing.

Cylinder- An oval shape connected by two parallel lines that creates a tube-like design.

Depth - The apparent distance from front to back or near to far in an artwork. Techniques of perspective are used to create the illusion of depth in paintings or drawings.

Diffuse light - Diffused light is a soft light with neither the intensity nor the glare of direct light. It is scattered and comes from all directions. Thus, it seems to wrap around objects. It is softer and does not cast harsh shadows.

Emphasis - An area or object within the artwork that draws attention and becomes a focal point.

Fixative - A liquid, similar to varnish, that is usually sprayed over a finished piece of artwork—usually a dry media artwork—to better preserve it and prevent smudging.

Focal point – The center of interest or activity.

Foreground - The ground or parts situated, or represented as situated, in the front; the portion of a scene nearest to the viewer (opposed to background).

Freehand – The use of any sort of utensil to make marks without the use and/or aid of guides such as rulers, straight edges, or even projectors and other tracing or reproduction elements.

Guideline - A lightly marked line used as a guide when composing a drawing or painting.

Hatching - Hatching is a shading technique used in both drawing and painting, where tone is built up through a series of thin strokes or lines that are more or less parallel. The lines can be short or long. Crosshatching is hatching done in two directions, one across the other.

Height - Distance upward from a given level to a fixed point: the height from the ground to the first floor; the height of an animal at the shoulder.

Highlight - An area or a spot in a drawing, painting, or photograph that is strongly illuminated. Those parts of a drawing that have the lightest tone. The white paper is left unshaded to create white highlights.

Horizontal - At right angles to the vertical; parallel to level ground.

Horizon line - Horizon line/eye level refers to a physical/visual boundary where sky separates from land or water. It is the actual height of the viewer's eyes when looking at an object, interior scene, or an exterior scene.

Hue - In color theory, a hue refers to a pure color—one without tint or shade (added white or black pigment, respectively). A hue is an element of the color wheel.

Kneaded eraser - An eraser that functions by adsorbing and picking up graphite and charcoal particles. They can be shaped by hand for precision erasing, creating highlights, or performing detailed work. They are commonly used to remove light charcoal or graphite marks and in subtractive drawing techniques.

Length - The measurement of the extent of something along its greatest dimension.

Light source - Any device serving as a source of illumination. A light source can be natural or artificial.

Line art - Any image that consists of distinct straight or curved lines placed against a (usually plain) background, without gradations in shade (darkness) or hue (color) to represent two-dimensional or three-dimensional objects. Line art emphasizes form and outline, over color, shading, and texture.

Medium - Refers to the materials that are used to create a work of art. The plural of medium is media. Some of the most common media are oil paints (paints that use oil to hold pigments together), tempera (pigments held together with egg yolk), marble (soft, white stone), and bronze (a metal used to cast sculptures).

Midtone - Midtoned values are in the middle of the tonal spectrum, neither dark nor light.

Muted – A dull tone or value.

Nib- The part of a quill, dip pen or fountain pen that comes into contact with the writing surface in order to deposit ink. Different types of nibs vary in their purpose, shape, and size, as well as the material from which they are made.

Optical mixing - Creating tones through knowledge of value and how the eye perceives values that abut or overlay each other.

Outline - The line by which a figure or object is defined or bounded; contour.

Overcast - Covered or obscured, as with clouds or mist.

Perpendicular - A straight line at an angle of 90° to a given line, plane, or surface.

Plane – In two-dimensional art, plane refers to a flat or level surface of a material body that can also be imagined in space. Planes of reference are imaginary planes to which the position, direction, and movement of the axes and surfaces of the forms of three-dimensional objects may be related.

Pointillism - A technique in which small, distinct dots are applied in patterns to form an image.

Reflection - An image given back by a reflecting surface, such as that of a mirror or still waters.

Reflected light - Indirect light that bounces off other objects in the same area that illuminates part of an object.

Rule of thirds - The rule of thirds is applied by aligning a subject with the guide lines and their intersection points, placing the horizon on the top or bottom line, or allowing linear features in the image to flow from section to section.

Scumbling - In drawing, scumbling is sometimes used to describe a random, scribbled texture, with figure eight and concave shapes used to create a spiky texture, rather than the common circular scribble.

Sphere - A round object or three-dimensional shape that looks like a ball.

Stippling - To paint, engrave, or draw by means of dots or small touches.

Stylistic - Refers to the resemblance works of art have to one another. Enough visual elements must be shared by enough works to make their combination distinctive and recognizable to a number of people.

Subtle - Delicate or faint and mysterious.

Tone - Refers to the light and dark values used to render a realistic object.

Topographic map - A map showing the relief features or surface configuration of an area, usually by means of contour lines.

Tortillon - A cylindrical drawing tool, tapered at the ends, and usually made of rolled paper, used by artists to smudge or blend marks made with drawing utensils.

Three-dimensional – An object appearing to have height, width, and depth.

Two-dimensional - Having the dimensions of height and width only.

Tubular - Having the form of or consisting of a tube.

Value - The lightness or darkness of tones or colors. White is the lightest value; black is the darkest. The value halfway between these extremes is called middle gray. An element of art by which positive and negative areas are defined or a sense of depth achieved in a work of art.

Vertical - Being in a position or direction perpendicular to the plane of the horizon; upright; plumb.

Width - Extent from side to side; breadth; wideness.

Made in the USA
Coppell, TX
08 July 2023

18882462R00116